IMAGES
of America
CHINESE IN SAN JOSE
AND THE
SANTA CLARA VALLEY

To Hui Hui
 Hope you enjoy this brief
glimpse of Chinese American
history in Santa Clara Valley.

 Lillian Gong-Guy George Ow

 September 2007

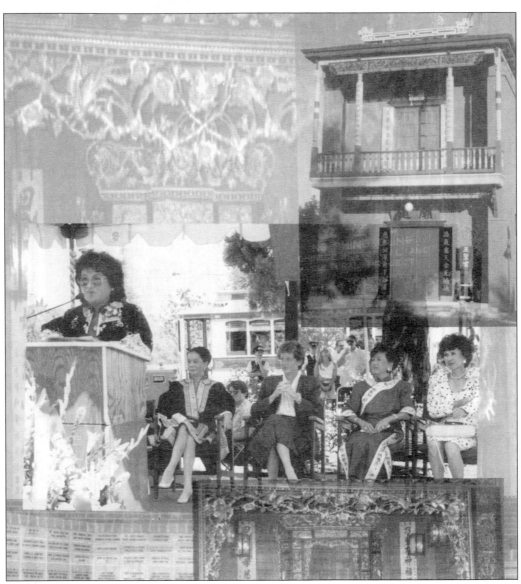

The Chinese Historical and Cultural Project (CHCP) dedicated the Ng Shing Gung Museum at the History Park in San Jose to the people of San Jose in September 1991.

IMAGES

of America

CHINESE IN SAN JOSE
AND THE
SANTA CLARA VALLEY

Chinese Historical and Cultural Project,
Lillian Gong-Guy, and Gerrye Wong

ARCADIA
PUBLISHING

Published by Arcadia Publishing
Charleston SC, Chicago IL, Portsmouth NH, San Francisco CA

Printed in the United States of America

Library of Congress Catalog Card Number: 2007924202

For all general information contact Arcadia Publishing at:
Telephone 843-853-2070
Fax 843-853-0044
E-mail sales@arcadiapublishing.com
For customer service and orders:
Toll-Free 1-888-313-2665

Visit us on the Internet at www.arcadiapublishing.com

This book is dedicated to the many community members who have supported the Chinese Historical and Cultural Project in its mission to preserve the proud history of Chinese Americans in the Santa Clara Valley.

CHINESE HISTORICAL AND CULTURAL PROJECT

EMBRACE OUR CULTURAL
HERITAGE TO ENRICH
GENERATIONS TO COME

五聖宮
REPLICA OF "NG SHING GUNG" 1888

DEDICATION : SEPTEMBER 29, 1991
SAN JOSE HISTORICAL MUSEUM
SAN JOSE, CALIFORNIA

承先啟後
繼往開來

The dedication plaque on the Heritage Brick Donor Wall in the garden adjacent to the Ng Shing Gun Museum is pictured above. (Courtesy CHCP.)

CONTENTS

Acknowledgments 6

Introduction 7

1. San Jose's Five Chinatowns: 1850s–1930s 9

2. In Search of Economic Prosperity 33

3. Organizations Serve Community Needs 61

4. A Community Arises 85

5. Community Leaders 101

6. Lasting Legacy 117

ACKNOWLEDGMENTS

The Chinese Historical and Cultural Project (CHCP) is proud this work acknowledges the role of Chinese Americans in the Santa Clara Valley. I wish to thank our community for lending its time, photographs, and stories for this historical publication. I also would like to thank the community for its support of CHCP and its programs over its 20 years. I must first mention coauthors Lillian Gong-Guy and Gerrye Wong for their stewardship of this organization and this project. And although they remain anonymous under the banner of CHCP, the members must also be thanked. In particular, I give enormous gratitude to my coeditors, Anita Wong Kwock and historian extraordinaire Connie Young Yu, for their tireless efforts in bringing forth the clarity, accuracy, and beauty of the stories. The authors also wish to thank Debbie Gong-Guy for her support and Richard Johns for his technical assistance. We are all indebted to Arcadia Publishing and its editor John Poultney, who not only guided us through the process, but also took an interest in our history.

To tell the story of Chinese people over 150 years in a limited space is a daunting task. It is worrisome that stories might be overlooked or individuals neglected. But I am confident that this work gives a fine overview into the lives of these pioneers as they transformed both themselves and the nation their descendants now call home. Most important to me is that we are giving face and providing voice to people who themselves might not be able to. To all of those who have contributed to this proud legacy, I give our most respectful and grateful acknowledgment.

—Dr. Rodney M. Lum
President
Chinese Historical and Cultural Project

INTRODUCTION

This great, rugged expanse of land became the "Valley of the Heart's Delight" in the late 19th century through labor and skill, and with technology and innovation, this region was known throughout the world as "Silicon Valley" by the end of the 20th century. Here is an extended success story with the Chinese playing a key role throughout.

"The Chinese Question" was the major controversy in 19th-century San Jose. A church was burned to the ground because a minister organized a Sunday school for Chinese children. A German American landowner was reviled and threatened because he made a contract with Chinese merchants. An anti-Chinese convention was held in San Jose touting the popular theme of the time, "The Chinese must go!" Why did they come? Like other immigrants, they came for survival and opportunity. Leaving impoverished villages in southern China in the mid-1800s, the Chinese took to the vast expanses of the Santa Clara Valley, developing the land for the great California industry of agriculture. They plowed fields, planted and harvested abundant crops of fruits and vegetables, and preserved and distributed them. They dug ditches and built walls, roads, and railroads. With gentrification, they were cooks and servants in homes and hotels. Facing racist attacks in one form or another, the Chinese survived by laboring long hours for lower pay and taking jobs whites rejected. During the depression of the 1870s, the Chinese were the scapegoats of a discontented labor movement.

In the winter of 1876–1877, U.S. Senate hearings took place in San Francisco calling for the testimony of "California's leading citizens" on the issue of Chinese immigration. Robert F. Peckham, owner of the San Jose Woolen Mills, stated that his business "cannot be carried on without Chinese labor." Railroad magnates Leland Stanford and Charles Crocker, who employed thousands of Chinese building the Transcontinental Railroad, testified to the capabilities and trustworthiness of the Chinese. Declared Crocker, "Without Chinese labor we would be thrown back in all branches of industry, farming, mining, reclaiming lands and everything else."

In 1882, the Chinese Exclusion Act was passed by Congress, banning Chinese laborers from immigrating and also denying their naturalization to U.S. citizenship. This act caused untold suffering, separated families, and created a society of single Chinese men. Making the Chinese ineligible for citizenship legitimized discrimination toward them in every aspect of American life. San Jose, like many cities, enacted ordinances to harass the Chinese, from restricting laundries to forbidding Chinese employment on public works. Following a series of violent expulsions of the Chinese throughout the West Coast, the Market Street Chinatown was destroyed by an arson fire on May 4, 1887, and San Jose citizens rejoiced. Had it not been for the courage and steadfastness of one John Heinlen, who leased his land to the Chinese, the outcome would have been tragic for the Chinese and a shameful blight on San Jose's history.

Heinlenville, which lasted for 44 years, was home base for all the Chinese in the valley and was beloved for its colorful festivals and community spirit. The customs and traditions were strong, and the children attended Chinese school after American school. But their aspirations and dreams began in the integrated classrooms of San Jose. When the last Chinatown was torn

down, young Chinese Americans started attending college and wanted to be professionals. They faced discrimination in housing and hiring and often changed vocations. Valley firms did not hire Chinese engineers in the 1930s.

The Exclusion Act was repealed in 1943, but the quotas remained. After the 1965 immigration act, families were reunited, and a new influx of immigrants from Hong Kong and Taiwan and other parts of Asia brought new talent and energy to the valley. The number continues to grow, as newcomers immigrate from Hong Kong, Mainland China, Taiwan, and Southeast Asia.

And here, the story changes: the Chinese, once the backbone of the agricultural industry, are now major players in an enormous technology-centered economy. Chinese engineers, entrepreneurs, and professionals have contributed their talents to what has become one of the most educated areas of the United States. Chinese shopping centers with gourmet restaurants are popular with all. Chinese culture has entered into the mainstream, with non-Chinese joining in Chinese language classes and activities.

Everything is forward-looking in the valley, and even this interest in things Chinese seems new. Twenty years ago, the Chinese Historical and Cultural Project (CHCP) was founded to educate, preserve, and promote Chinese American history and culture in the Santa Clara Valley. "There was a Chinatown in San Jose?" people ask in surprise—there were five. And we have a story to tell. Here we fill a major gap, connecting past and present with this book, our lasting legacy to future generations.

—Connie Young Yu, Historian
Chinese Historical and Cultural Project

One

SAN JOSE'S FIVE CHINATOWNS

1850s–1930s

First Market Street Chinatown	1866–1870
Vine Street Chinatown	1870–1872
Second Market Street Chinatown	1871–1887
Woolen Mills Chinatown	1887–1902
Heinlenville (Sixth Street Chinatown)	1887–1931

The Chinese played a major role in developing and building the Santa Clara Valley, and their settlements have a colorful history. Yet from the very beginning, their presence in *Gum San*, "Gold Mountain," was threatened with challenges. By 1852, there were 25,000 Chinese in California working in mining or as laborers, servants, and laundrymen. During the 1870s, California suffered an economic depression with resulting labor unrest. The Chinese, willing to work at menial jobs for low wages, faced resentment from unemployed whites. With the economy failing, the Chinese were attacked by angry mobs and persecuted by discriminatory legislation, locally and statewide.

Facing desperate conditions in the villages of southern China, floods, drought, and famine, the Cantonese persisted in coming to California despite the anti-Chinese movement in America. On the eve of the Chinese Exclusion Act, the population of Chinese immigrants peaked in 1882, with over 39,500 entering the state. To withstand the harassment and hostility toward them, the Chinese banded together in communities. These Chinatowns not only offered physical and spiritual sanctuary, they also became havens for celebrating holidays with kinfolk, headquarters for employment, and a place for shopping and recreation.

From 1866 to 1931, there were five Chinatowns that served the needs of immigrant Chinese as they sought their fortunes in the rapidly growing California economy. One followed the other as home base for the Chinese, providing a safe harbor for Chinese laborers, merchants, and ultimately families and making their survival possible in stormy times.

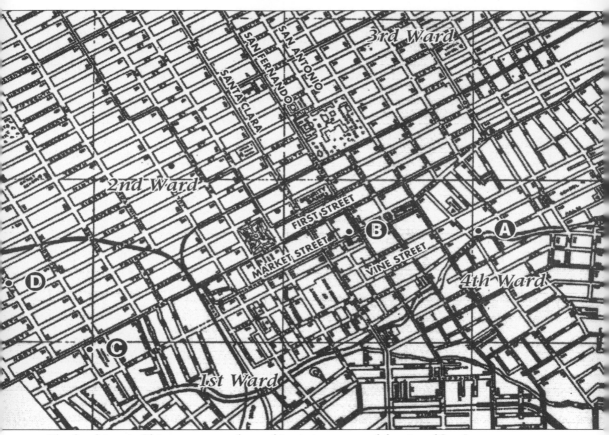

The five historic Chinatowns were located in various parts of the city of San Jose.

(A) Vine Street Chinatown (1870–1872), was where residents moved when the Market Street Chinatown burned. Five hundred people lived on this street of restaurants, lodging houses, brothels, gambling houses, and merchandise stores. When the Guadalupe River flooded, the community had to evacuate again.

(B) The first Market Street Chinatown (1866–1870) burned in a mysterious fire. The Second Market Street Chinatown, also called the "Plaza Chinatown" (1872–1887), expanded beyond the original site, with many more stores, three restaurants, a large temple, and a theater. By 1876, over 1,400 people lived in this home base for the all the Chinese working in the valley.

(C) The Woolen Mills Chinatown (1887–1902) was one of the two Chinatowns that emerged after the 1887 arson fire of the Market Street Chinatown. On Taylor Street along the Guadalupe River, it was the site of San Jose Woolen Mills, one of the earliest manufacturing firms in the city, which employed Chinese workers since 1869. Buildings of wood frame and brick were constructed for stores and lodging, and a temple and theater were also built under the direction of Ng Fook, who died a year later. When Chin Shin ("Big Jim"), who ran a large cannery, left for China, the town declined, and a fire in 1902 finished it off. The site was excavated by archeologists in 1999 during the upgrade of Route 87.

(D) Heinlenville (1887–1931), on Cleveland Avenue, was the longest-lived Chinatown of San Jose, built by John Heinlen on his land near a residential neighborhood despite vehement protests from the city. Designed by San Jose's famous architect, Theodore Lenzen, Heinlenville was surrounded by a fence to protect it from harm. Heinlenville's colorful history ended during the Depression in 1931. The site became San Jose's corporation yard, destined in the 21st century for redevelopment.

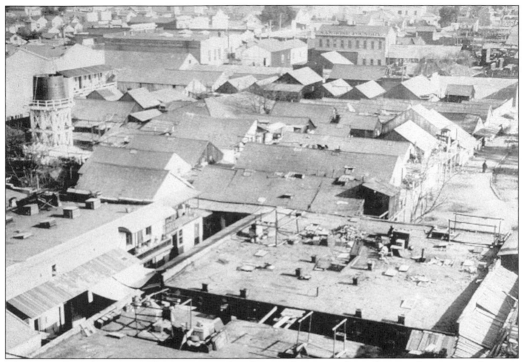

The second Market Street Chinatown was bustling with activity from shops and cottage industries manufacturing cigars, shoes, clothing, furniture, and brooms. By the 1880s, Chinatown was expanding southward along First Street. Downtown merchants and residents pushing plans for the beautification of San Jose abhorred this growing Chinese presence in such a central location of the city. A hundred years later, this would be the site of one of San Jose's finest and largest hotels, the Fairmont San Jose. (Courtesy History San Jose.)

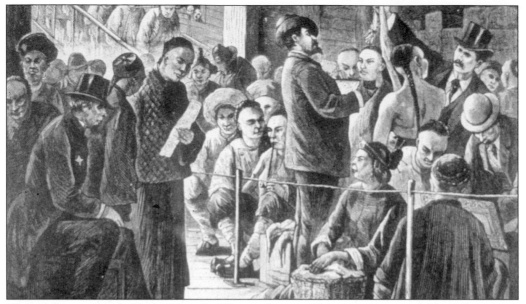

Cheap labor was needed for building the West, and young Chinese were imported from the seaport city of Canton. They were crowded into holds of ships, and when they arrived in San Francisco they were sized up and taken to job sites. Chinese merchants were partners with American companies in labor contracting. (Courtesy Chinese Historical Society of America.)

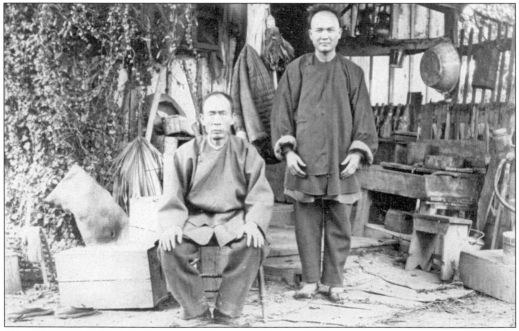

Two Chinese workers are seen on the Heron Ranch on Hostetter Road in San Jose. The older worker on the left was affectionately called "Ah Bok" by the family, meaning respectfully "old uncle." According to Edith Heron, who as a young child knew Ah Bok, he worked loyally for decades on the ranch, doing everything from tending the orchard to babysitting the children. Immigrating as a laborer, he never had his own family and returned to China as an old man, dying the day he arrived. (Courtesy Connie Young Yu.)

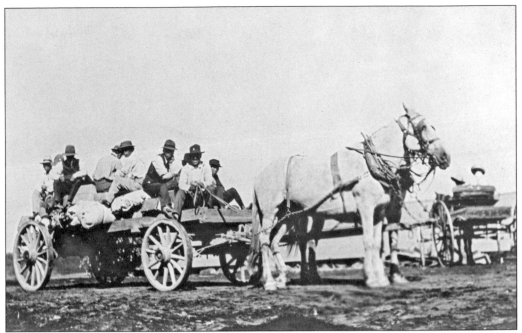

A farmer or rancher needing hands would go to a store in Chinatown that did labor contracting and pick up Chinese by the wagonload. Banned from American political and social life, the growing numbers of Chinese in the valley needed a home base. Chinatown provided all their material needs, serving as a social, cultural, and employment center as well. (Courtesy History San Jose.)

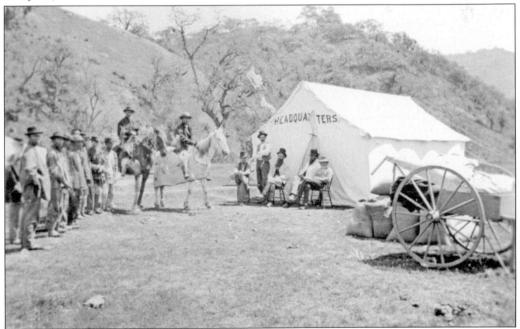

Chinese workers largely driven out of mining counties by the 1860s found ready employment as laborers on construction projects. This Chinese crew was contracted to work on Mount Hamilton Road for the Lick Observatory, *c.* 1876. (Courtesy History San Jose.)

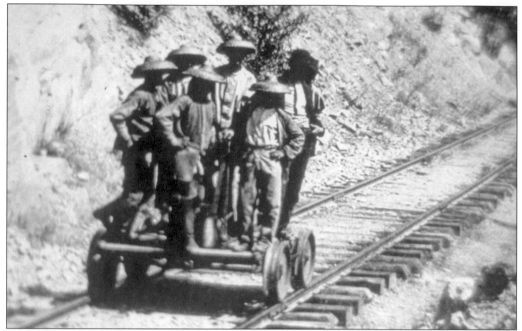

Chinese were hired in building the Transcontinental Railroad (1865–1869), and their industry, ingenuity, and courage were legendary. After the golden spike ceremony, there were thousands of experienced Chinese construction workers ready for employment on other transportation projects. Chinese worked on the San Jose Railroad and, in the 1870s, built the Santa Cruz–Monterey Line for the South Pacific Coast Railroad, suffering heavy casualties in this hazardous work. (Courtesy Southern Pacific.)

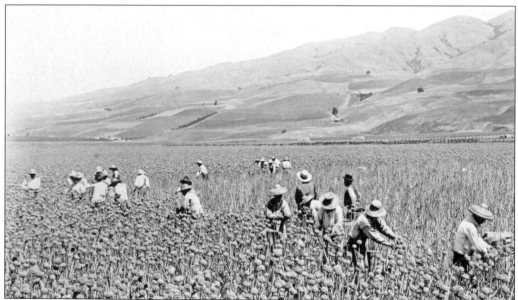

Chinese workers were employed in every aspect of agriculture, from clearing land to plowing, planting, and harvesting. Here they are working in the onion fields in bountiful Santa Clara Valley, which largely due to their labors was known as "the Valley of the Heart's Delight." (Courtesy California Historical Society.)

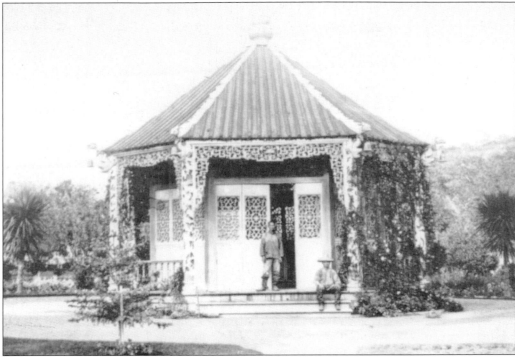

In the New Almaden Quicksilver Mine, the Chinese were hired as manual laborers. Here in 1885, Chinese workers pose in front of the pagoda given as a gift to the mine owners by representatives of the Emperor of China during negotiations for a contract for mercury in the 1850s. (Courtesy New Almaden Quicksilver Mining Museum.)

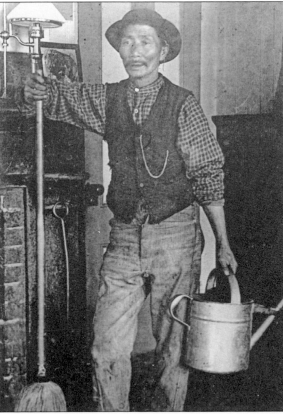

Ah Sam, who performed the many tasks of a caretaker, was one of the most familiar figures at the New Almaden Mine property. Living and working there for decades, he was popularly known as "China Sam." (Courtesy New Almaden Quicksilver Mining Museum.)

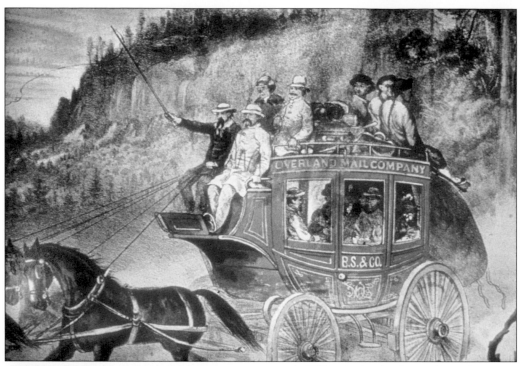

A 1877 painting by Aaron Stein depicting a stagecoach of the Overland Express, later to be Wells Fargo, shows three Chinese riding high and backward. (Courtesy Wells Fargo History Museum.)

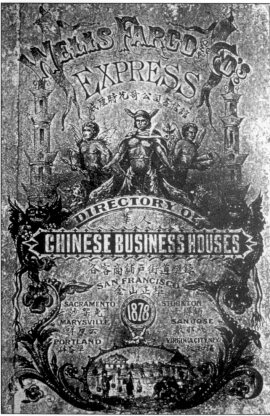

The enterprising, hard-working Chinese contributed substantially to the economy of the young state of California. Their role in commerce was important enough for Wells Fargo to publish a directory of Chinese business houses. The 1878 directory lists 77 Chinese businesses in San Jose alone. (Courtesy Wells Fargo History Museum.)

In this 1888 letter, Chinese merchants are instructing Wells Fargo to give all mail and packages to an American agent "for the Ah Fook Chinatown." There were great expectations for the new Chinatown at the Woolen Mills, but when Ah Fook, the community's leader, suddenly died, business declined, and people began moving out. (Courtesy Wells Fargo History Museum.)

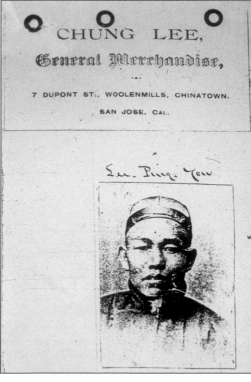

As the Woolen Mills Chinatown declined, a number of stores relocated to Heinlenville, including Chung Lee. Dupont was the main street of the Woolen Mills. Dupont was also the name of the street intersecting Cleveland Avenue in Heinlenville, along with Clay Kearny, also names of streets in San Francisco. Dupont *Gai* (or *street*) was the thoroughfare in San Francisco's Chinatown, where newly arrived Chinese immigrants felt welcome and safe. (Courtesy Federal Archives, San Bruno, California.)

17

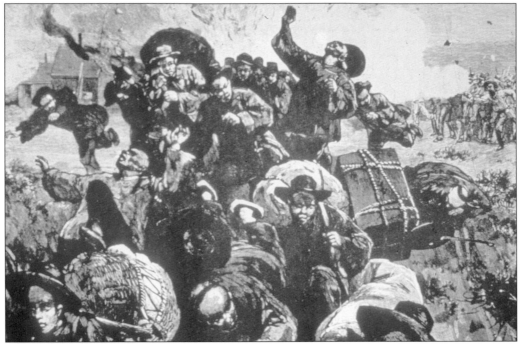

The massacre of Chinese miners at Rocks Springs, Wyoming, on September 2, 1885, and the expulsion of the Chinese community were the most brutal incidents of the anti-Chinese movement. The perpetrators were heralded instead of punished, and the expulsion movement spread throughout the West. (*Harper's Weekly*, September 26, 1885.)

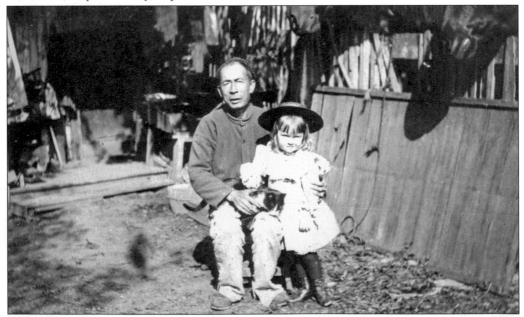

Despite furor over Chinese labor, farmers in the valley regarded the Chinese as indispensable, and there was mutual trust and often friendship. Photographed by her father at age three is Edith Heron with Bok in the family's Live Oak Orchard on Hostetter Road, San Jose, in 1899. (Courtesy Connie Young Yu.)

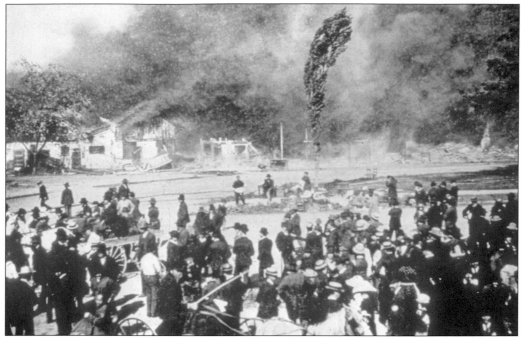

In March 1887, Mayor Charles W. Breyfogle and the city council voted unanimously to eliminate the Plaza Chinatown on Market Street on the grounds that it was a public nuisance and a health hazard. On May 4, before any official action was taken, an arson fire razed the entire Chinatown. A headline in the May 5 *San Jose Evening News* read, "Among the Ruins Chinese and Whites Digging for Valuables in the Ashes Chinatown Swept from the Map of San Jose." (Courtesy History San Jose.)

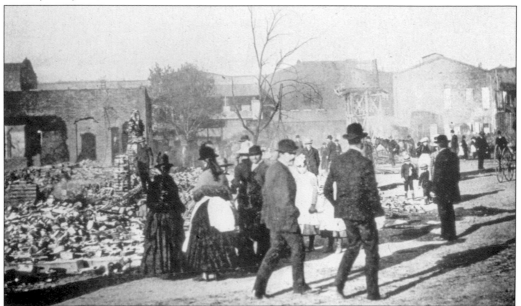

While the city was rejoicing over what was perceived as the end of Chinatown, a group of Chinese merchants was making plans with a fearless, principled landowner named John Heinlen for the building of a new Chinatown. (Courtesy History San Jose.)

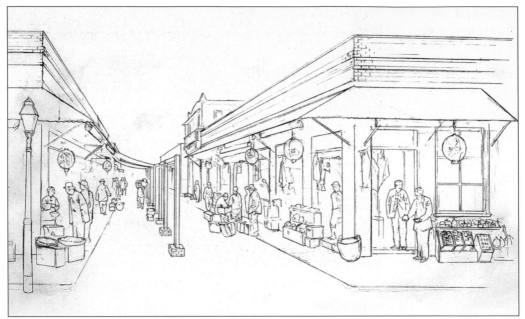

No photographs have been found of the Woolen Mills Chinatown, so artist John Lytle did a rendering of a street scene of this short-lived community after careful archeological and historical research. The original oil painting is in the Ng Shing Gung Building at History Park in San Jose. (Courtesy John Lytle.)

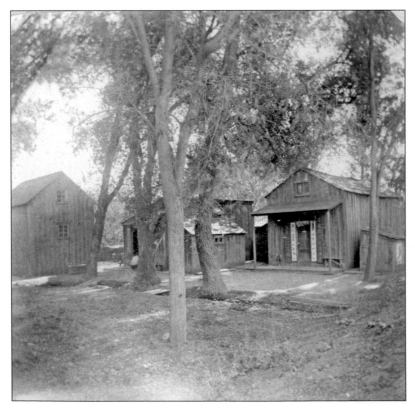

As early as 1868, the Chinese found growing strawberries on leased land in the Santa Clara Valley a lucrative business, and as sharecroppers, they grew a variety of berries and vegetables. This photograph from the 1890s, identified by the photographer as "Chinatown, Brokaw Road," shows that the Chinese, as tenant farmers, expected to work and stay awhile. (Courtesy Barbara Lumbard.)

Early immigrant Chinese men wore queues, a hairstyle imposed upon them by the Manchu dynasty. After China's 1911 revolution and the establishment of the republic, men cut off their queues and wore Western clothes. The women, however, continued to dress in the traditional late Ch'ing style. (Courtesy Osla Young.)

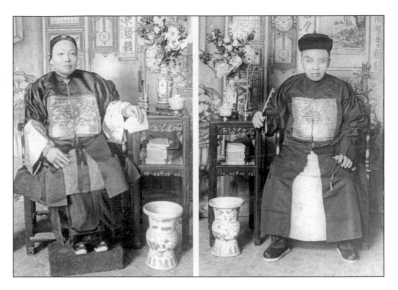

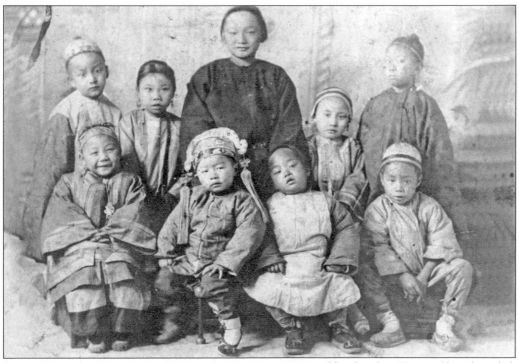

Lynne Shew (back row second from right), born in 1890, and her brother George (first from left in the back row), dressed in their finest Ch'ing dynasty clothing, pose with their cousins for this photograph. Children were precious to the Chinese community, which was largely made up of unmarried laborers. The Exclusion Law allowed merchants to send for their wives, and a few fortunate Chinese were able to change their status from laborers to merchants by establishing ownership of a store in Chinatown. (Courtesy Pearl Shew Lee.)

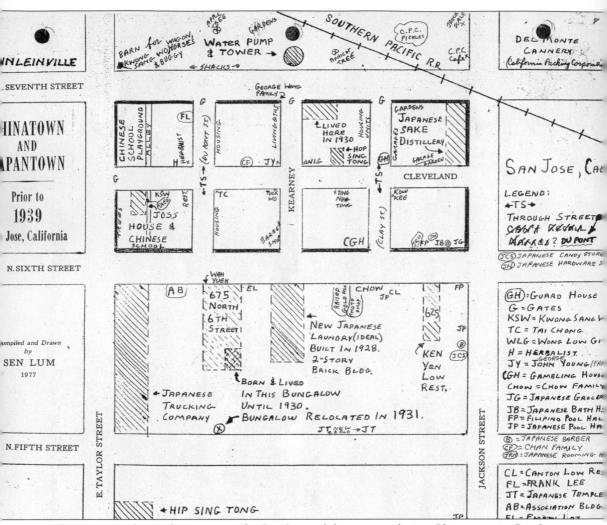

This is a map drawn from memory by Sen Lum of the most enduring Chinatown in San Jose. It was commonly called "Heinlenville" after John Heinlen, a landowner who leased land to the Chinese immediately after the burning of the Market Street Chinatown, despite vehement protests by San Jose's city council and anti-Chinese citizens. The side streets were named after streets of San Francisco's Chinatown, but the main street was Cleveland Avenue. The site of Heinlenville is in today's Japantown at Sixth and Jackson Streets. Used by the city of San Jose as a corporation yard for decades, it is being sold for redevelopment. (Courtesy Sen Lum.)

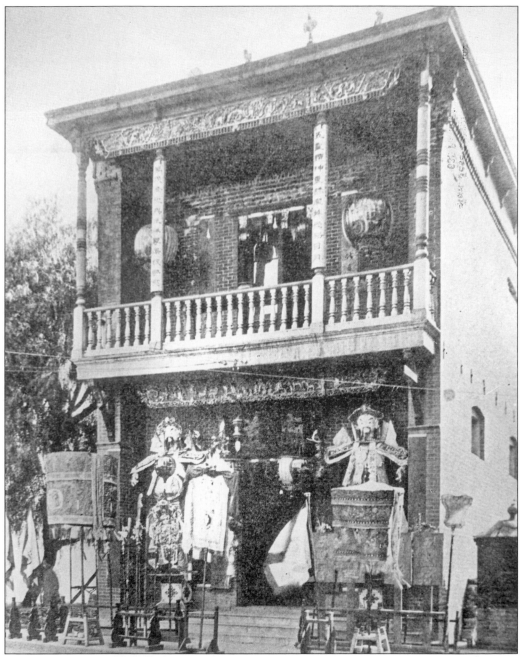

The *mui* or temple (Ng Shing Gung in the 1920s) was the most splendid structure in Heinlenville and was built and maintained with funds from the people. It was the central focus of the community, decorated splendidly for festivals with effigies, lanterns, and banners. The upper floor housed the splendid gilded altar with five deities. The lower floor was used as a town hall, hostel, and memorably for those who grew up in the Chinatown, a Chinese school. Today at History Park in Kelley Park, San Jose, a replica building houses a museum of Chinese American history on the first floor and the restored original altar upstairs. (Courtesy History San Jose.)

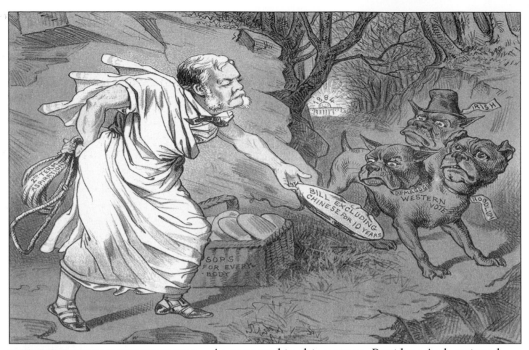

As portrayed in this cartoon, President Arthur signed the Chinese Exclusion Act in 1882 to placate the western states. In 1892, the Geary Act was passed, extending exclusion another 10 years and requiring all Chinese laborers in the United States to carry a photo passport. The Chinese fought the Geary Act all the way to the Supreme Court but were defeated. (Courtesy Chinese Historical Society of America.)

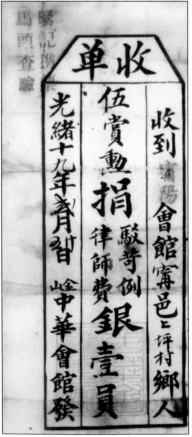

The Chinese Six Companies, representing the Chinese in America, was a benevolent society that settled disputes between Chinese and fought legal battles against discrimination. In one of their boldest moves, the group hired legal counsel to fight the Geary Act of 1892, which required the registration of all Chinese laborers. Every Chinese was asked to donate a dollar, a day's wages at the time, toward court costs. This is a receipt from the Six Companies for the dollar contribution by Ng Seung Fun of San Jose. (Courtesy History San Jose.)

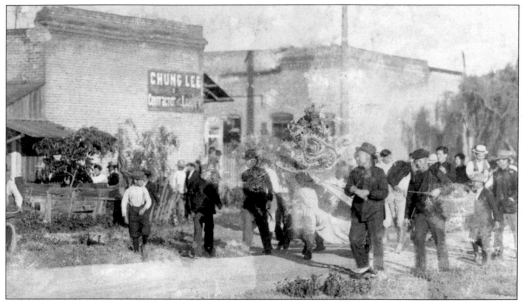

Festivals, particularly the Lunar New Year, were highlights of Chinatown life. Heinlenville was known for its colorful and elaborate observance of *Da Jui*, an all-souls day. Here a lively lion dance and firecrackers chase away evil spirits. The man on the right is carrying a large basket of firecrackers for a long and noisy celebration. The sign on the brick building has the name of a general store, Chung Lee, which moved to Heinlenville from the short-lived Woolen Mills Chinatown. (Courtesy Eugene Chinn.)

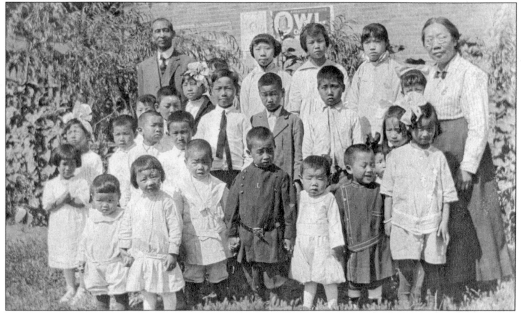

The Chinese Methodist Episcopal Church was on Fifth and Jackson Streets. This picture, taken in the back of a store in Heinlenville, shows children with the minister and his wife. Parents who worshipped at the temple saw no problem in having their children attend Sunday school at the Chinese Methodist Episcopal Church. The whole community enjoyed the church picnics, and during Christmas, everyone went to the church for a party. (Courtesy Osla Young.)

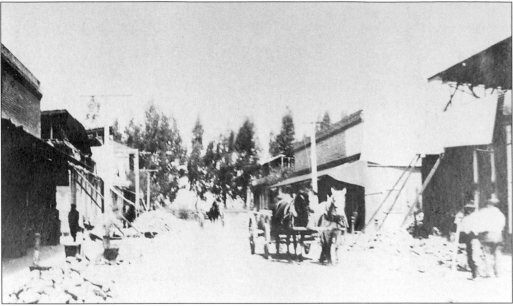

On April 18, 1906, the earthquake caused heavy damage in Heinlenville, but there were no casualties. Buildings were repaired as soon as possible, with some stores adding more space and amenities. (Courtesy History San Jose.)

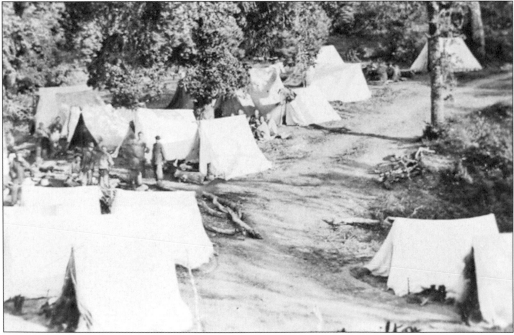

The Chinese of Heinlenville fled to St. James Park and lived in tents, like the other residents of San Jose who were fearful that their homes would collapse on them. San Franciscans looking for refuge outside the burning city swelled the population of San Jose. San Jose author Jessie Juliet Knox wrote days after the quake, "Chinatown, San Francisco is no more. We will soon have a bigger Chinatown in San Jose." That didn't happen. Heinlenville rebuilt but never grew much larger, and a huge new Chinatown emerged in San Francisco. (Courtesy History San Jose.)

Red Cross drives took place throughout the United States during the First World War. Heinlenville, with some of its own "over there," showed support by putting the Stars and Stripes in store windows. These Chinese women joined the local drive, rolling bandages and preparing packages for the soldiers overseas. (Courtesy Connie Young Yu.)

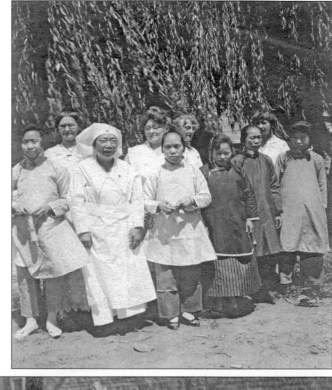

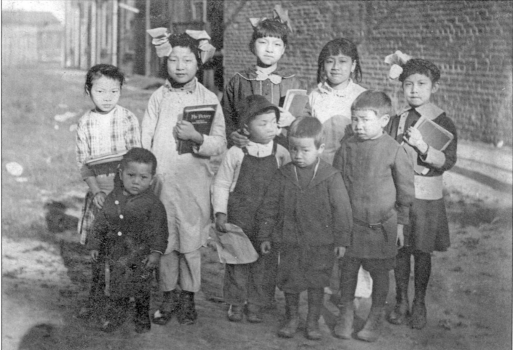

The children of Cleveland Avenue are about to cross the railroad tracks to Grant School. After American school, they were required to attend Chinese school, which was held at the Ng Shing Gung temple. (Courtesy Connie Young Yu.)

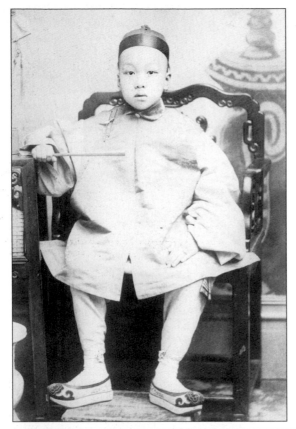

Although born in America, Young Quong Duck was raised in a traditional family and posed like all the children of his generation in Chinatown, dressed in Ch'ing dynasty clothing, for his formal picture. Young lived in San Jose's Chinese community until the 1940s. (Courtesy Osla Young.)

Brothers were close in Heinlenville, and friends were just as close. Here are (from left to right) Stephen Chow, Bill Young, Edward Chan, Sam Chow, and Sam Lee, who kept their fraternal ties throughout their lives. (Courtesy Connie Young Yu.)

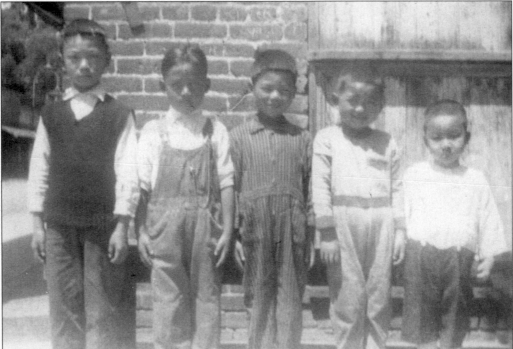

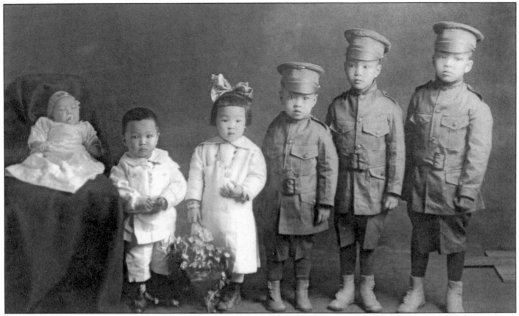

The well-attired children of Young Quong Duck posed formally for a Chinatown photographer, c. 1918. Showing their patriotism like many boys in San Jose during the years of the First World War, the older boys wore army uniforms similar to their doughboy heroes, such as Sing Kee. From left to right are Baby Mary, Shang Kwan, Lil, Bill, Bobo, and George. (Courtesy Osla Young.)

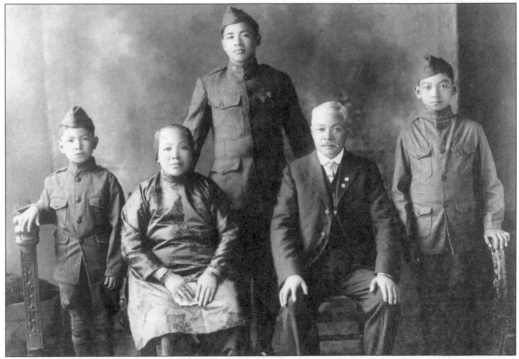

Sgt. Lou Sing Kee was born in 1895 on Lumber Street in Saratoga. His pioneer parents, Mr. and Mrs. Chung Kee, brothers Willie and Johnny celebrate his return home to San Jose from France in 1919 with a formal family portrait. (Courtesy Connie Young Yu.)

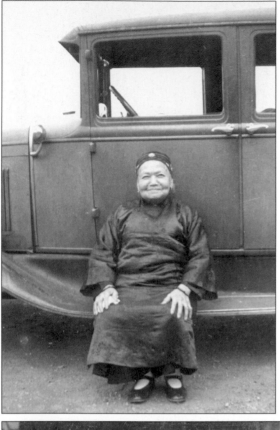

Shee Chan, wife of Sai Tai Young, joined her husband in America in 1862 and lived in San Jose as the matriarch of a family of nine children. Here she proudly sits on the running board of a new car owned by her son, Young Quong Duck, head of the Hop Sing Tong, a Chinese fraternal organization, in San Jose. (Courtesy Osla Young.)

Little Charles Young plays in front of his family's dry goods store. His father, Young Quong Duck, was the proprietor and, like several other merchants, ran a gambling parlor in the back. (Courtesy Osla Young.)

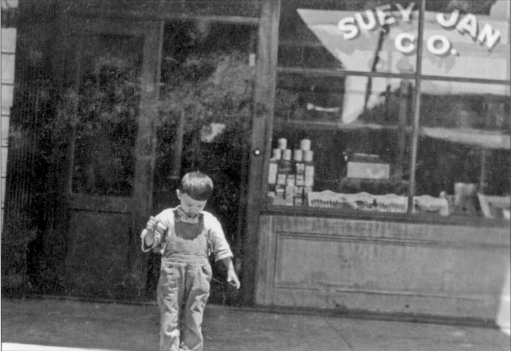

In 1930, during the Depression, many San Jose farms and businesses were foreclosing. Heinlen Company soon would go bankrupt. Hosting two city folk, Soong Quong Young (right) sits on a bench outside the general store at 34 Cleveland Avenue she and her husband called home for decades. They had raised two sons in their beloved Heinlenville, a Chinatown about to disappear. (Courtesy Connie Young Yu.)

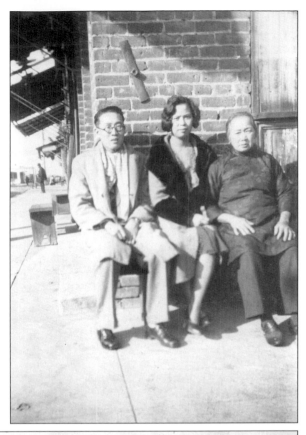

The buildings on Cleveland Avenue were demolished in 1931, and some residents moved to nearby Japantown. Pictured with their 1924 Nash are young James Chan, sister Fanny, and mother Wing Chan. San Jose, once an agricultural capital, was changing. The new generation of Chinese Americans was not interested in farming or shopkeeping. Young James Chan wanted to go to college and be a professional. (Courtesy Dr. James Chan.)

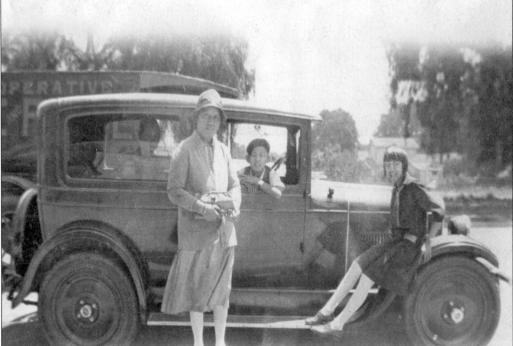

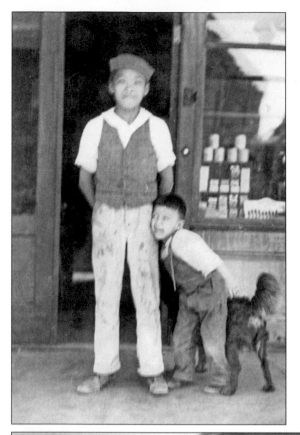

The Chinese stores that served a farming community found business scarce during the Depression. Bill (left) and Jack Young and their dog, pictured here in front of their store, still had their share of fun and fellowship. Their father gave credit to many a jobless worker and needy family. (Courtesy Osla Young.)

By the 1930s, the era of San Jose's insular Chinatowns had ended. It was a time of civic involvement and watching world events. China was invaded, and Chinese Americans joined protests over the U.S. sending scrap metal to Japan. Gen. Choy Ting Kai, top aide to China's commander-in-chief, Chiang Kai-Shek, stopped in San Jose on his nationwide tour to win support for China's struggle, a much-heralded visit to Chinese residents. (Courtesy Osla Young.)

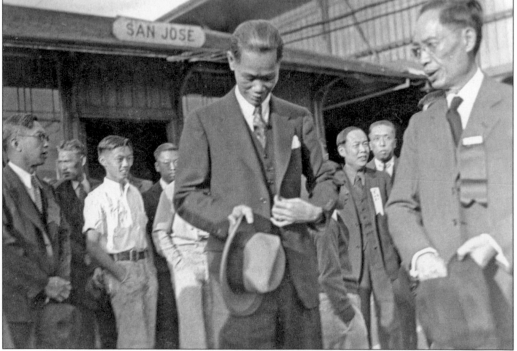

Two

In Search of Economic Prosperity

Without a home base in the valley, the Chinese in the 1930s had to start all over again. For many it was back to laundries, truck farming, small shops, and restaurants. When World War II ended, the Chinese looked forward to raising families in the valley without the Exclusion Law hanging over their heads, but barriers in hiring and housing remained. The Chinese in Palo Alto had white friends help them buy houses. It wasn't easy being the first Chinese on the block, or to run the first business or be the first professional in town. But these Chinese American "firsts" had a pioneer heritage and the belief that they belonged.

Flower growing, the last agricultural surge in the valley, flourished because of the tenacity and know-how of Chinese and Japanese farmers. Valley flowers were famous for their outstanding quality and varieties. Chrysanthemums, the regal flower of the Chinese, were worn by fans at Stanford football games. The Chinese believed in real estate, and during an era when Asians were forbidden to own land in California, they bought farmland in the name of their American-born children. Technology was replacing agriculture as the major industry of the valley. By the 1970s, many a Chinese flower grower in Palo Alto, Mountain View, Cupertino, San Jose, and Morgan Hill was virtually sitting on a gold mine. Land, needed for housing near tech headquarters, was suddenly too valuable for growing mums, asters, and roses. But the Chinese weren't driven out as they were in the 19th century; they stayed and went into business. They opened supermarkets and banquet-style restaurants and developed shopping centers. Chinese engineers, dentists, doctors, and educators found opportunity in growing communities throughout the valley. There was still the glass ceiling, but Chinese professionals began making great strides because those before them weren't afraid to take the first step.

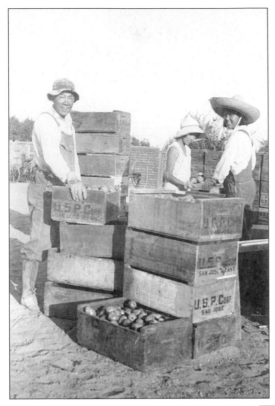

In the 19th century, the Chinese were the county's primary agricultural workers. *Sunshine, Fruit and Flowers*, a book promoting the Santa Clara Valley in 1898, never mentions the Chinese, boosting: "Every month in the year ripens a crop of some kind in the open air." A cannery is praised as having fruit "all packed by white men and women." Here Chinese pack freshly harvested produce for shipping by freight across the country. (Courtesy Osla Young.)

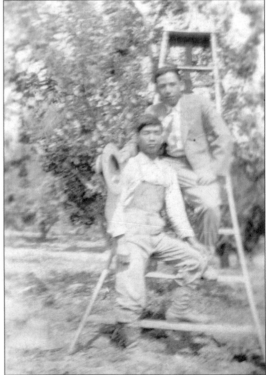

Gong Poouy, pictured in overalls in 1907, was a farm worker by day and a Chinese political writer at night. His well-dressed friend also once picked fruit. They might be working in a pear orchard in this picture, but San Joseans were labeled "prune pickers," as the region was known as the "prune capital of the world." (Courtesy Connie Young Yu.)

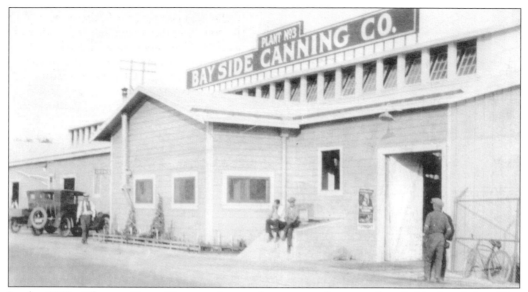

In the 1920s, Thomas Foon Chew took over the canning business founded by his father, Yen Chew, and expanded it into a large operation. He built the Bayside Cannery on a tract of land he owned in Alviso, the shipping point from Santa Clara County to San Francisco. Chew was known as the "asparagus king" for a method he developed in the Sacramento Delta for canning and preserving asparagus. The Alviso plant was a complex of facilities, including housing for workers. His family residence was in Los Gatos. Pictured from left to right are Mrs. Lee Gum Ching Chew, Francis, Lonnie, grandmother Mrs. Yen Chew, Taidy, Henry, Tom Foon Chew, and Charles Chew. Tom Foon also had a canning operation in Palo Alto that packed tomatoes, apricots, pears, and peaches. (Courtesy Gloria Hom Collection.)

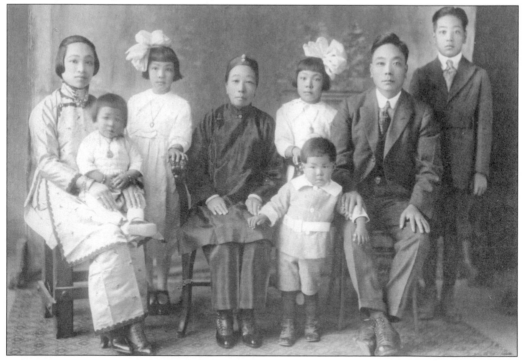

Charles and James, sons of grower Lum Toy, bring in a wheelbarrow of asters. The family farmed in Palo Alto in the early 1940s. A year's income could hinge on the success or failure of one harvest. These faces reflect confidence in a bountiful harvest in a peaceful time before America entered the war. During World War II, many growers converted their flower fields to vegetables as part of the war effort. (Courtesy Lum Toy family.)

Theodore S. Chan (right), owner of T. S. Chan Nursery, is pictured with a friend in the greenhouse in San Jose. His son, Gordon Chan was the first Chinese American to commercially grow roses, starting in the 1980s. (Courtesy Anita Chan.)

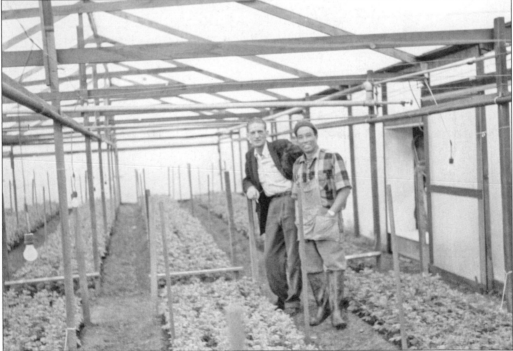

Pon Chew is pictured in a shade hat on the Chews' Palo Alto farm in 1940. In 1951, the Chews bought another farm on Dempsey Road in Milpitas that was later sold to a developer. (Courtesy Wai Ying Chew.)

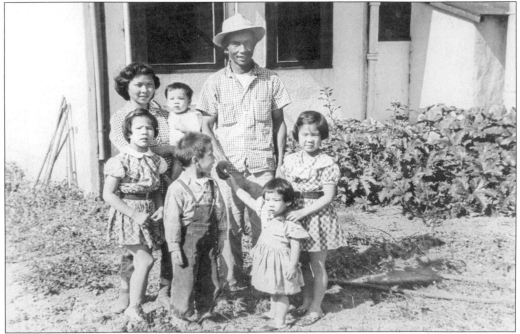

In 1954, William and Kay Mock and their children pose in front of their home on their farm in Sunnyvale. They owned 100 acres for growing vegetables and flowers. From left to right are (first row) Lixia, Stewart, May, and Arlene; (second row) Kay, Henry, and William. (Courtesy William Mock.)

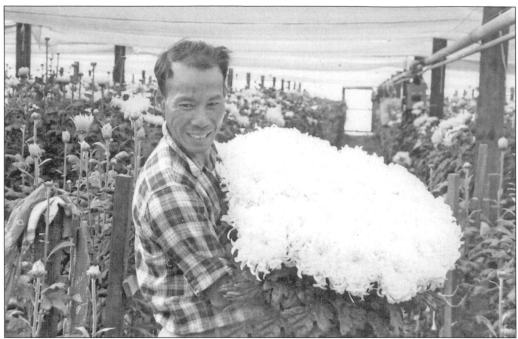

In the 1950s, the chrysanthemum had become the most profitable flower variety in the valley. Hong Chan, with his large blooms, was the owner of Hong Chan Nursery in San Jose. (Courtesy Maria Kwong.)

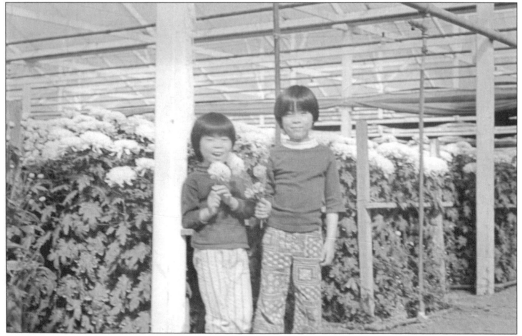

More profitable than asters, chrysanthemums became the single biggest agricultural product in the country by 1960. Janet and Juliet, daughters of Gordon and Anita Chan at T. S. Chan Nursery, knew how to pick the smaller buds off a stem so that one large mum could bloom. (Courtesy Anita Chan.)

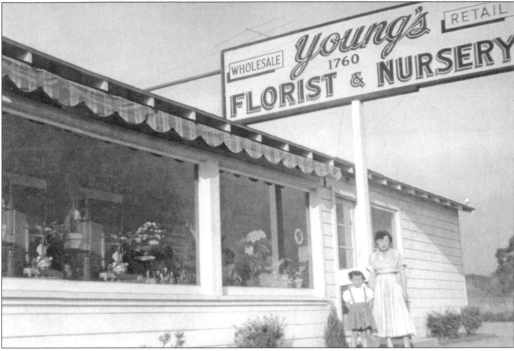

Lonnie Young stands with her daughter Wanda by their store in 1956. She and husband Fred grew asters and chrysanthemums on their Palo Alto land from the late 1930s, and after selling a land parcel for the expansion of Highway 101, they opened a florist nearby that they operated for over 40 years. (Courtesy Fred Young Jr.)

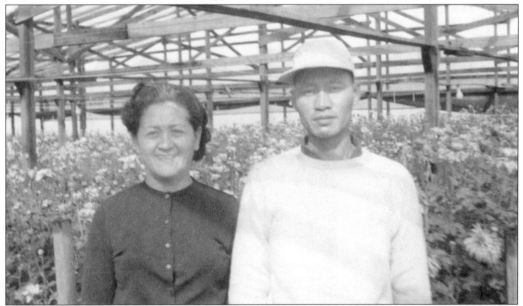

Y. K. Fong learned the nursery trade from his grandfather, who farmed in San Mateo in the 1940s. His Y. K. Fong Nursery opened in 1960 and was a thriving nursery business for over 20 years in Sunnyvale. Mr. and Mrs. Fong raised five children on the farm, so they had many hands to help them harvest the chrysanthemum crop each season on their five-acre property. (Courtesy Paul Fong.)

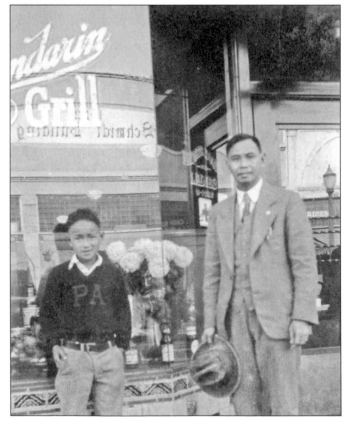

Wing's restaurant was owned and operated in 1924 by Wing Chan, who moved out of Heinlenville Chinatown to Fourth and Jackson Streets, which is now Japantown. His son, Dr. James Chan, opened his dental office on Fourth Street and kept his practice there ever since. (Courtesy Dr. James Chan.)

Designed by architect Birge Clark, the Mandarin Grill was opened in 1926 by Leung Kee (pictured with his son Jimmy) with hard-earned savings and loans. Advertised as "serving American and Chinese dishes," the family-run restaurant had two doors, one for casual dining and the other for dining in a formal setting. During the Depression, diners could get a good and hearty meal starting at 35¢. (Courtesy Wallace Leung.)

Mountain View's first Chinese restaurant, Qui Hong Low, was opened in 1936 by On Liu at 156 Castro Street. On and Rose Liu made their own noodles, grew bean sprouts, killed their own poultry, and made weekly trips to San Francisco Chinatown for supplies. During World War II, business flourished as the city became a hub for Moffett Field personnel, and the advertised chop suey—a purely American Chinese dish—and chow mein attracted customers and kept the cooks busy. In 1968, the Lius opened a second restaurant in a developing city that would soon be a high-tech hub. (Courtesy David Liu.)

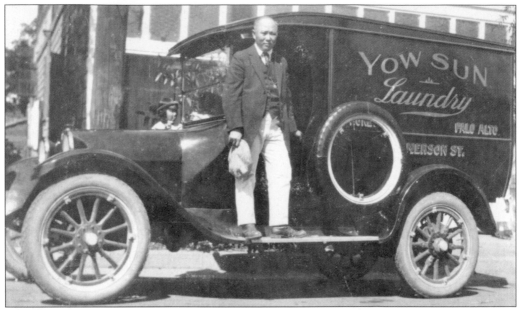

In 1912, Ngum You Jew began a laundry business in a storefront-style home at 647 Emerson Street in Palo Alto, a city that had denied a restaurant license to Chinese a few years earlier. He and his wife, Rose Tong Jew, raised nine children, all graduates of "Paly High." The laundry business prospered, and the Jews opened two restaurants in the city. (Courtesy Doris Jew.)

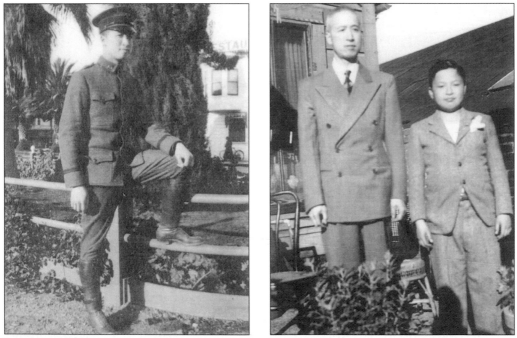

Lawrence Chew Sr., pictured in 1925, was sponsored into Seale Military Academy of Palo Alto by his employer, Pres. Ray Lyman Wilbur of Stanford University, who saw his promise as a student. Born in Canton, Chew immigrated in the early 1920s, worked hard in various occupations, and was finally able to bring his wife over from China in 1935. Son Lawrence Chew Jr. became very successful as a pharmacist and businessman. (Courtesy Larry Chew.)

42

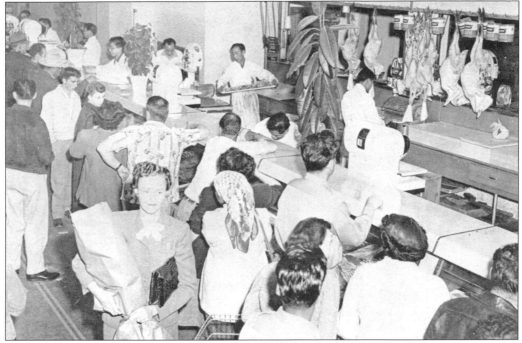

Originally from the Fah Yuen region of China, the Carl Kwong established State Meat Market on 150 East Santa Clara Street in San Jose in 1934. The market provided jobs for Kwong's kinfolk and also room and board for employees. Kwong named the business State Meat Market because of the proximity to San Jose State Teachers College. (Courtesy *Chinese Argonauts* by Gloria Hom.)

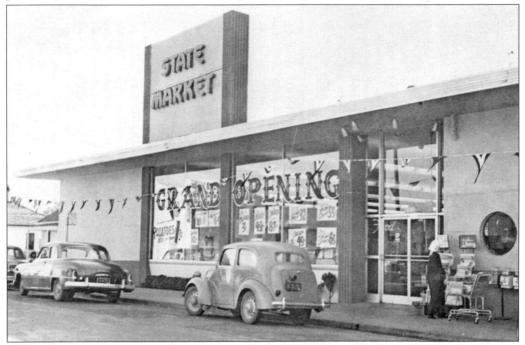

Dick Kwong and cousin Carl Kwong opened State Market grocery store at 182 South Murphy Street, Sunnyvale, in 1941. (Courtesy *Chinese Argonauts* by Gloria Hom.)

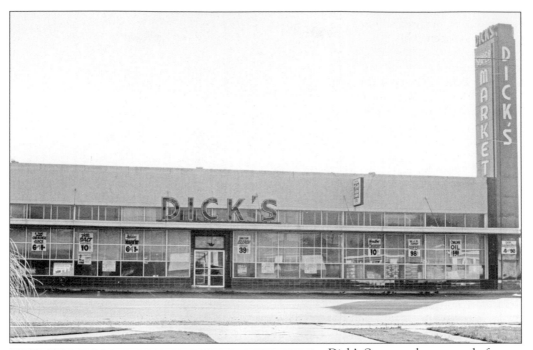

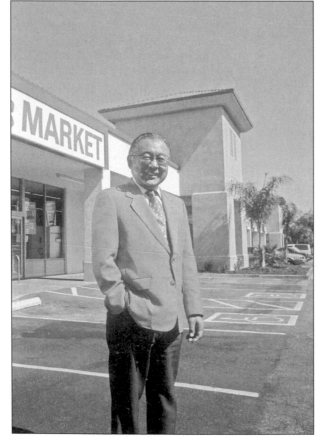

Dick's Supermarket, named after proprietor Dick Yee, opened its first San Jose store in 1948 on Fourth Street. In its day, it was considered the largest and most modern grocery store in the South Bay. (Courtesy Gene Yee.)

Gene Yee, Dick's son, expanded the family business, purchasing 15 acres of prune orchard on Bascom Avenue for a shopping center in 1951. At the height of operations, there were a total of 15 stores throughout the South Bay, making Dick's the largest independent chain in the region. With 50 years spent in the grocery business, Gene was president of California Grocers Association in 1974 and was inducted into Grocers Hall of Fame in 1997. (Courtesy Gene Yee.)

Samuel Leong, pictured with Lee Y. Shatt, opened his market in 1951 at one of the busiest locations in Mountain View: Bayshore Highway at the corner of Moffett Boulevard, which was later named Leong Way in his honor. His store served the personnel of Moffett Field, community families, and travelers on this main thoroughfare. (Courtesy Sam Leong Jr.)

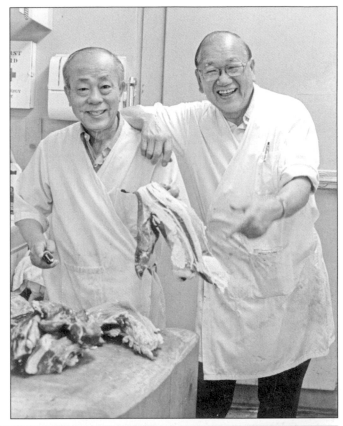

Mr. and Mrs. Lee Yee Choy opened the Palace Market in downtown San Jose in the 1940s. Their son, Jerry Lee, was active in downtown civic organizations and is pictured in 1962 showing daughter Gerimae how to use the meat slicing machine, bringing a third generation to work in the store. (Courtesy Mabel Lee.)

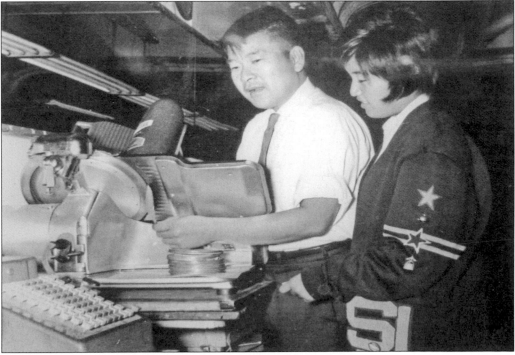

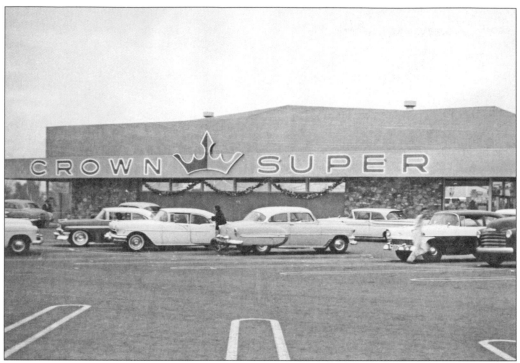

Crown Supermarket was opened in 1959 by the Lee family on Almaden Avenue and Vine Street in San Jose, one of six stores. Pictured are five of the operating principals, from left to right: Herbert Leong, Bob Lee, Darwin Lee, Elwood Lee, and Thomas Lee. All were World War II and Korean War veterans. Dawson Lee, not pictured, was serving in Berlin. (Courtesy of Bob Lee.)

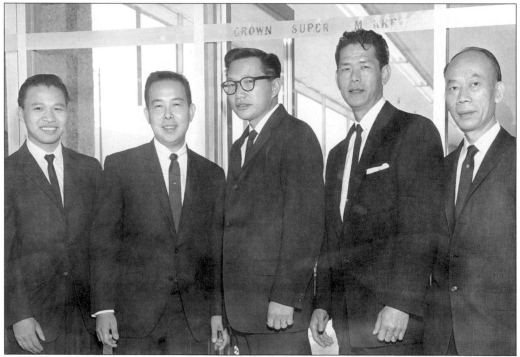

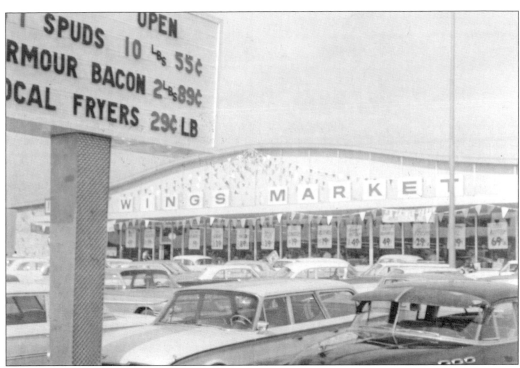

The family of Wing Don opened a new Wing's Market in Campbell in 1965. Wing Don had previously operated a Salinas store supplying meat and staples to commissaries for the Mexican Bracero Program. Son Jim Don developed the Campbell site into a shopping center in 1991. The modern market, with a wide row of checkout stands, did brisk business in an area of rapidly growing neighborhoods. (Courtesy Jim and Mitzi Don.)

Bill Kee was general manager of the National Dollar Store, one of the largest department stores in San Jose. During the World War II years, the windows of Kee's store were soaped with anti-Japanese taunts, prompting Kee to put up a sign, "This is a Chinese-owned business." In the 1930s, Kee was one of the first Chinese Americans to join the San Jose Rotary Club, the Masonic Temple, and the Shiners. (Courtesy Gerrye Kee Wong.)

Leland Chew was one of the first Chinese to establish a drugstore outside the San Francisco Chinatown area. Giant Thrift in San Jose was the first large neighborhood pharmacy owned and operated by Chinese American pharmacists. In 1965, Leland sold it to his cousin, Larry Chew, who maintained the thriving business until 1985. (Courtesy Larry Chew.)

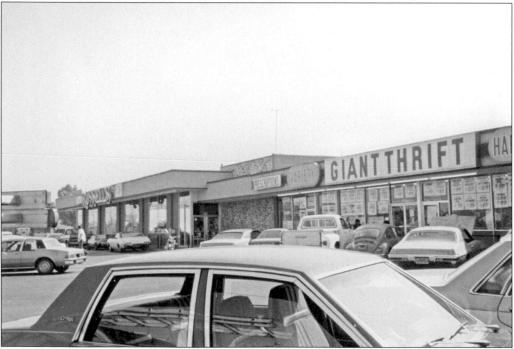

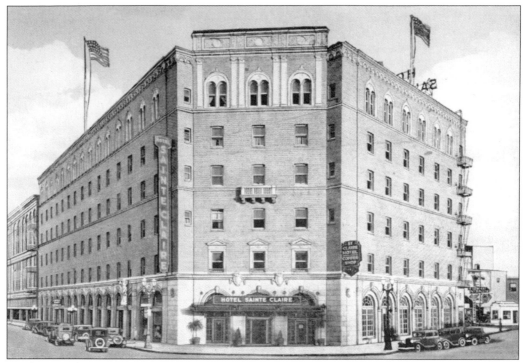

Stephen Lin, a Taiwanese American entrepreneur, bought the historic St. Claire Hotel and restored it to its former glory with modern amenities in 1980. He was a leader in revitalizing downtown San Jose by renovating neglected sites and old buildings, including the landmark Bank of America. A supporter of the arts, he served as a trustee of Opera San Jose. (Courtesy Stephen Lin.)

Shanghai-born Pauline Fong grew up in Tokyo loving fashion and, in 1987, became the first Chinese American to open an upscale boutique in San Jose, The Collection at El Paseo de Saratoga. From left to right are May Komaki, Pauline Fong, Susanne Chow, and Mrs. T. T. Way. (Courtesy Wilson Fong.)

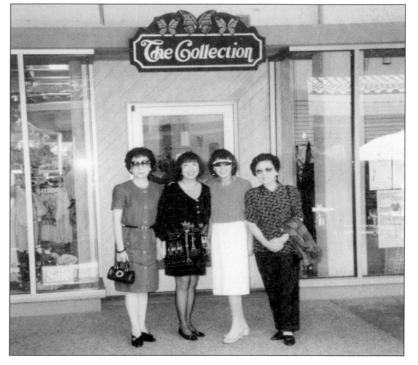

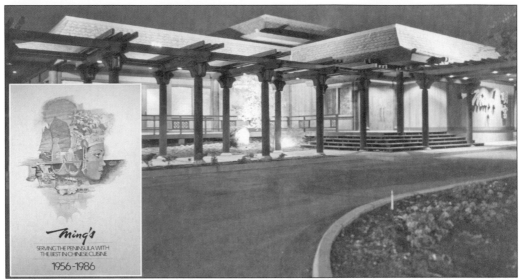

Ming's of Palo Alto, founded by a partnership in 1956 on El Camino Real, was an immediate hit. Loyal clientele followed when Ming's moved to Embarcadero Road into a new building designed by Phillip Choy, architect and historian. Owner Dan Lee designed the menu, created the ambiance, and made it an award-winning gourmet restaurant. For three decades, Ming's was the place for Stanford varsity teams, executive gatherings, and family celebrations. (Courtesy Phillip Choy.)

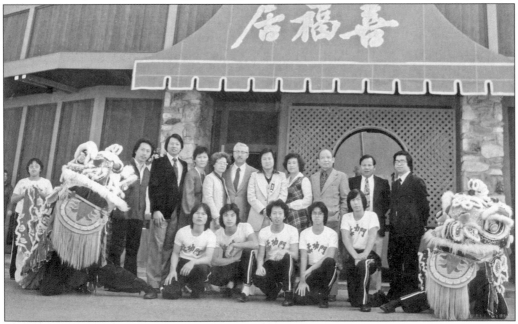

Family members are pictured at the celebration of the 10th anniversary of Chef Chu's of Los Altos in 1980. Shown from left to right are proprietors Lawrence (second from left under the awning) and Ruth Chu, Maggie and Bennett Ho, Norman Chu, Yolanda Cheng, and Mike Chu. A second generation of the Chu family has joined the management team, marking the 37th year of the operation, the oldest operating Chinese restaurant in the Santa Clara Valley under the same owner. Participating in benefit events, Lawrence Chu is among the Bay Area's popular celebrity chefs. (Courtesy the Chu family.)

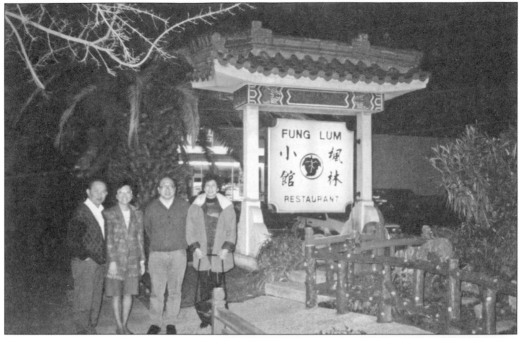

Fung Lum was a popular, beautifully appointed restaurant in Campbell that closed in 2005. Its owners, the Pang family, donated the restaurant's elaborate interior to Foothill Community College in Los Altos Hills. All the furnishings and wall decorations are in the Chinese Heritage Room next to the library, a place for meetings and activities of diverse heritages. Some of the owners, Ken and Eva Pang (left), are seen with friends in front of restaurant. (Courtesy Ken Pang.)

Albert Jew, son of laundry owner Ngum You Jew, created an electronics company in a Palo Alto garage with Fred Kruse. Named after the co-owners, Alfred Electronics, employing 150 at its height, made amplifiers and other devices, sold directly to the consumer. (Courtesy Doris Yep.)

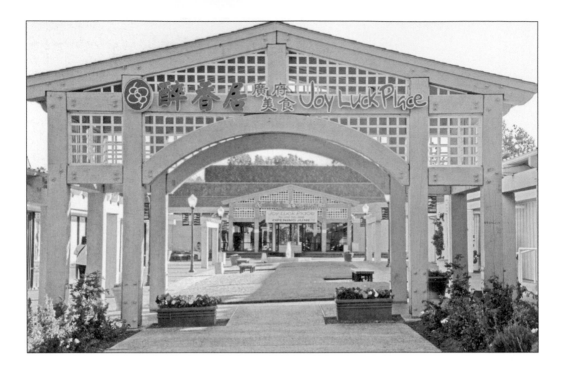

Joy Luck Place opened in 1998 on Wolfe Road in the Cupertino Village Shopping Center. There are two restaurants, one for a quick bite and another for leisurely dining, family meals, and business meetings. Partners and managers are, from left to right, Bailey So, Stanley Kung, Patrick Tsim, Teresa Tsim, Sye Wye Kwong, Judith Kwong, Milton Chan, Laura Chan, Suzanne Pau, Peter Pau, Maria Ho, Donald Ho, and Peter Zhao. (Courtesy Maria Ho.)

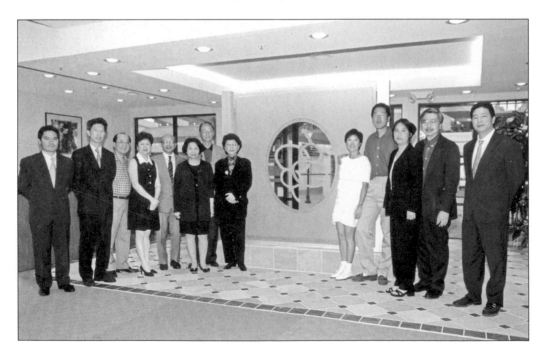

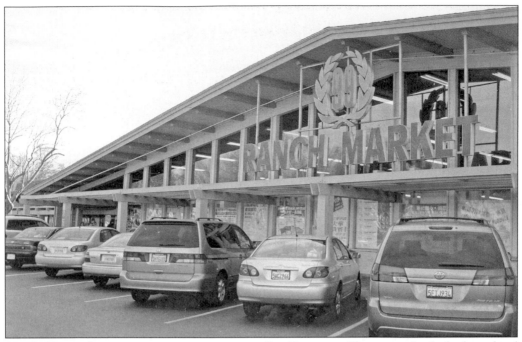

Ranch 99 is a phenomenon—no more going to San Francisco Chinatown for fresh choy, dried oysters, sauces, or specialty cuts of meat. It's all available, right in this suburban neighborhood. The store at Cupertino Village is always bustling, even more so during the Lunar New Year, with festive decorations and food displays. Every kind of Asian ingredient can be found in the store, many products imported from Taiwan, China, and Southeast Asia. The majority of Cupertino's residents are Chinese, largely first generation from Taiwan, but the entire population has diversified its tastes in culture and food, and non-Chinese enjoy shopping here too. (Courtesy Kou-ping Yu.)

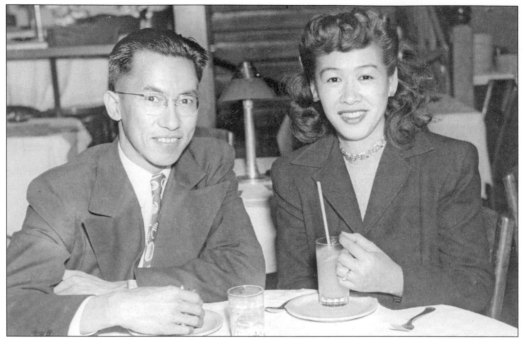

A true native of San Jose's Chinatown where he was born and bred, Dr. James Chan, pictured with his wife, Evelyn, returned to his roots to become San Jose's first Chinese American dentist in the 1940s. Practicing in the same block where his family once owned a restaurant, Dr. Chan continues to work in the practice alongside his son, Dr. Robert Chan. (Courtesy Dr. James Chan.)

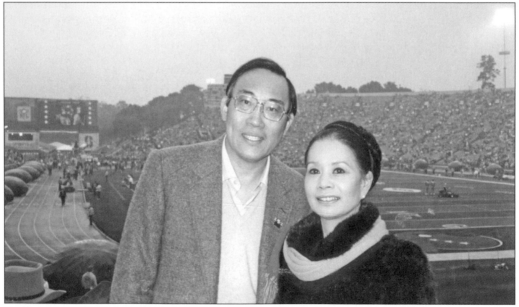

Dr. Ernest Gong-Guy was one of the early Chinese American family physicians caring for patients in Willow Glen. He later moved his office to the Almaden area of San Jose. He and his wife, Lillian, were early supporters of the performing arts. Lillian was the first Chinese American woman to serve on the boards of local non-profit organizations ranging from health care to the arts. (Courtesy the Gong-Guy family.)

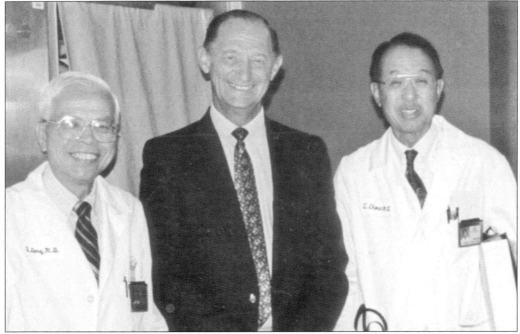

Dr. Christopher Chow (on the right) was a leader of Kaiser Permanente Santa Clara's expansion. Joining Kaiser in 1964 as an internist in intestinal medicine, Dr. Chow became department chief and also taught at Stanford and Santa Clara Valley Medical Center. Pictured with Drs. Bock Dong and Ray Clark, Dr. Chow was appointed physician-in-chief of the valley's largest hospital in 1978. (Courtesy Dr. Christopher Chow.)

Stanford graduate Dr. Peter Yee became San Jose's first Chinese American anesthesiologist in 1950, when he began a 40-year career in private practice operating out of O'Connor Hospital. He and his wife, Palo Alto native Helen, raised their family in the Willow Glen area. Here he happily passes his medical baton to son, Dr. Martin Yee, who began his own practice of internal medicine in 1997. (Courtesy Melinda Yee.)

Art Fong is one of the great pioneering engineers in the valley. During World War II, he contributed to the development of radar, and in 1946, he was invited by William Hewlett, who was in the Army Signal Corps, to join a fledging start-up in Palo Alto. In the early 1960s, Fong's innovations represented 27 percent of Hewlett-Packard's annual revenues. Entire corporate divisions resulted from his products: impedance-measuring instruments, signal generators, and the calibrated microwave spectrum analyzer. Art received international recognition from the Institute of Electrical and Electronic Engineers for his contribution to "Microwave Measurement Techniques and Instrument Design." (Courtesy Art Fong.)

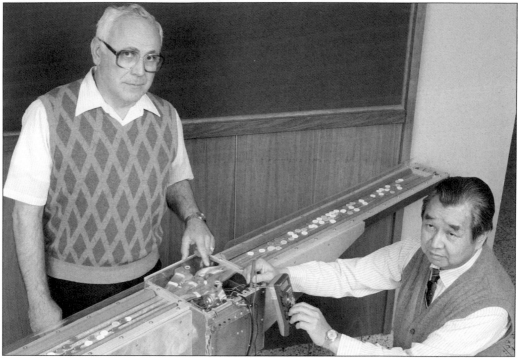

Robert Lee (right) and Len Haslim were named "Inventors of the Year" by NASA in 1985. They are pictured with their invention, the electro-explosive de-icing device used in aviation. (Courtesy NASA Ames Research Center.)

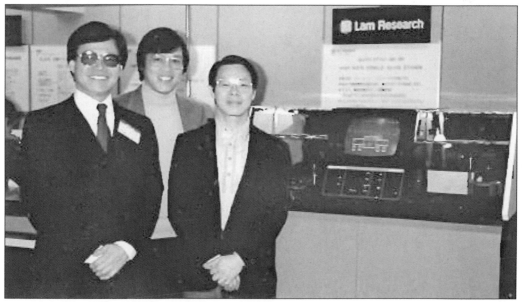

Raised in Vietnam and educated in Toronto, Lam Research Company founder David Lam introduced Lam Research's product, a semiconductor manufacturing system, at SEMICON Japan in 1982. Lam Research went on to become a market leader and a publicly traded company in 1984. Joining David are two of his brothers, Brian (right) and Godwin (center), Lam Research's very first investors. (Courtesy David Lam.)

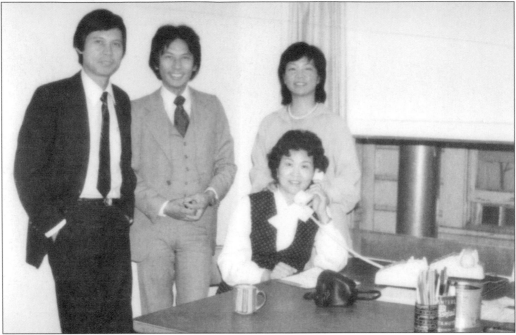

Brothers Chester Wang and Stanley Wang started a commercial real estate development business, Pacific Rim Financial Corporation, in 1976. The Wangs developed properties into industrial complexes and housing. They were the first to build a Chinese shopping center in Silicon Valley. (Courtesy Chester Wang.)

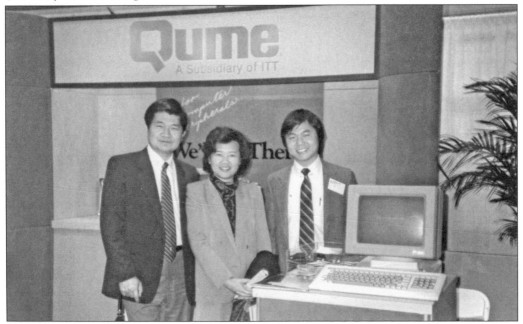

David Lee (at left) is pictured with his wife, Cecelia, and a visitor at Qume, which Lee founded in 1973 and grew from a company of two to hundreds of employees. The Lees are philanthropists who have donated college scholarships and fellowships and sponsored film documentaries on China. (Courtesy Cecelia Lee.)

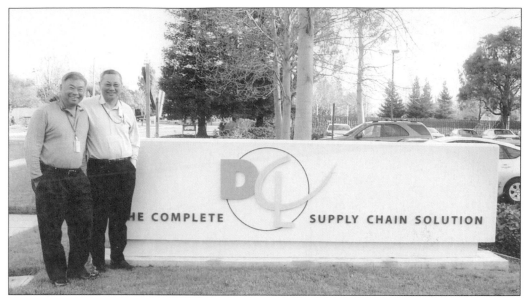

Norman and David Tu started business in a small office above a beauty parlor. DCL grew into a full-service supply chain company integrating e-commerce order fulfillment with back-end logistics service. In honor of their parents, who inspired their success, the brothers sponsored a Self-Help for the Elderly assisted living home in Santa Clara, the Zung Siew Longevity Garden. (Courtesy Norman Tu.)

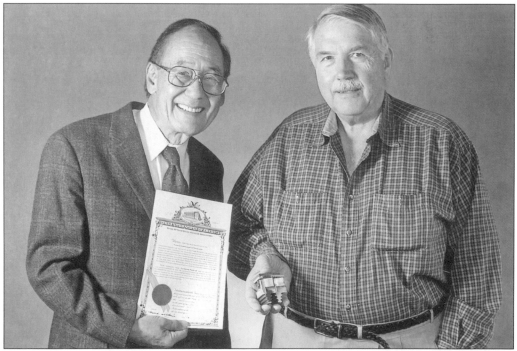

James Mark Gate, a Westinghouse design verification manager at the Sunnyvale plant, developed rotating blade seals and a sub-base for machines used for steam flow through submarine turbines. Pictured with associate John Fehley, James displays the patent certificate of one of three devices he invented at work. (Courtesy James Gate.)

In 1961, Don Tang (right) joined Lockheed Missiles and Space in Sunnyvale, and 30 years later, he became president and general manager of the Space Systems Division, managing over 17,000 employees. He was inducted into the National Reconnaissance Office Pioneer Hall for developing national intelligence satellite programs. Pictured from left to right are Kevin, Sandra, wife Rose, Don, and grandchildren Kathryn and Lauren in front. (Courtesy Don Tang.)

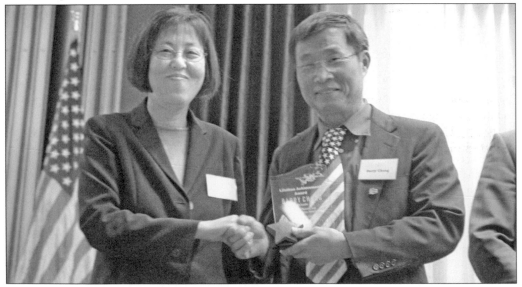

Dr. Belle W. Y. Wei is dean of the College of Engineering at San Jose State University. Dr. Wei was the recipient of the first Chang-Lin Tien Education Leadership Award for Asian American leaders in higher education. She serves on the board of Vision New America and is pictured honoring the organization's founder, Barry Chang. (Courtesy Andre Nguyen.)

Three

ORGANIZATIONS SERVE COMMUNITY NEEDS

When the first Chinese immigrants arrived, they were met with less than a hospitable welcome. To survive in this hostile environment, they formed district associations, collectives of kinsfolk from the same geographic area in China. District associations aided new arrivals by finding them employment and shelter. Along with district associations were the smaller groups of family associations and *tongs*, or fraternal societies. All these organizations played an important role in the life and work of the Chinese in America, offering protection, livelihood, and a social outlet.

As the second and third generation of Chinese Americans emerged in the Santa Clara Valley, new organizations formed not only to serve the needs of the Chinese but also to promote special interests and to foster civic involvement. The Chinese American Citizens League (CACL) began in the 1950s as a men's group promoting American citizenship and sponsored social events, sports teams, and educational activities. The Stanford Area Chinese Club formed in 1965, organizing a Chinese language school and cultural and social activities.

In the 1960s, women's clubs such as the Chinese American Women's Club (CAWC) and the Chi Am Circle provided social service programs benefiting the community as well as a providing social activities and a support network among members.

In the 1970s and 1980s, non-profit organizations such as Asian Americans for Community Involvement and Asian Law Alliance emerged out of community concerns, civic issues, and new immigrant needs. With the growth and development in Silicon Valley, Asian Americans groups such as Asian American Manufacturers Association (AAMA) and Monte Jade converged to network and establish forums for high tech issues, innovations, and international trade.

As the Chinese population continues to grow in the valley and diversity is celebrated, established organizations regroup and new ones emerge serving human needs and enriching the quality of life in the community.

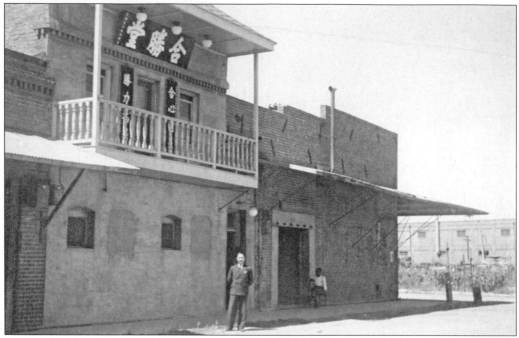

Hop Sing Tong, a venerable fraternal organization, opened new headquarters on Sixth Street in 1932. It was formerly located in Heinlenville Chinatown, demolished the year before. The new building was a meeting place for members from all over the valley and hosted events for the local community during Chinese festivals. (Courtesy Olsa Young.)

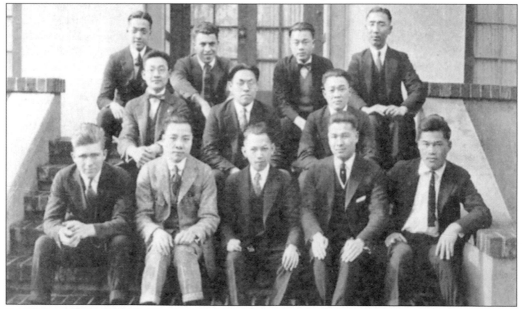

Formed in 1919, Stanford's Chinese Students Club raised funds for a clubhouse needed for Chinese students who were denied housing in the dormitories. Pictured on the steps of the clubhouse are, from left to right (first row) Don Chase, G. Chan, Frank Chuck, N. Y. Yue, and Y. D. Hahn; (second row) K. T. Chu, H. C. Wong, and J. N. Foy; (third row) C. H. Lee, Milton Dreyfus, Wu T'aam, and K. L. Chi. (Courtesy Bernadine Chuck Fong.)

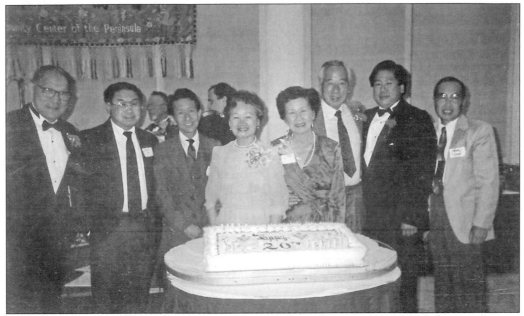

In 1968, the Chinese Community Center of the Peninsula (CCCP) was founded in Palo Alto to promote Chinese American culture. The group sponsored a Kung Fu exhibition in 1970. It has served monthly senior lunches for over 30 years. Members at their 20th anniversary are, from left to right, Dale Yee, Joseph Jew, Louis Pang, Roberta Yee, Mary Wong, Wally Wong, Tim Gee, and Henry Gee. (Courtesy Roberta Yee.)

A sports enthusiast, Dale Yee spearheaded the Chinese Little Olympics at Foothill College for 10 years to give young Chinese Americans an opportunity to compete with one another in track and field events. It attracted hundreds of families to participate from as far away as Hawaii. This popular activity continues annually. (Courtesy Roberta Yee.)

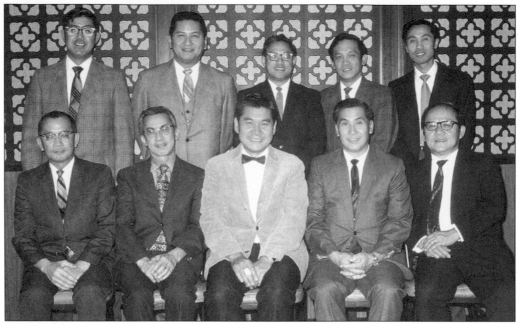

The Chinese American Citizens League of Santa Clara County (CACL) was formed as a men's social service club in 1956 to foster social and cultural activities for the growing Chinese community. Early presidents were, from left to right (first row) Frank Mar, James Chan, Raymond Quon, Leo Mark, and Tuck Lee; (second row) Victor Wong, Al Wong, Ted Fong, Bob Lee, and Edwin Mar. (Courtesy CACL.)

The first Chinese language school was opened by the CACL in East San Jose in the early 1960s to help its members' children maintain their Cantonese language and ethnic identity. In 1974, the classes moved to Blackford High School in West San Jose, teaching Mandarin classes as well as courses in Chinese cooking and Chinese culture. (Courtesy CACL.)

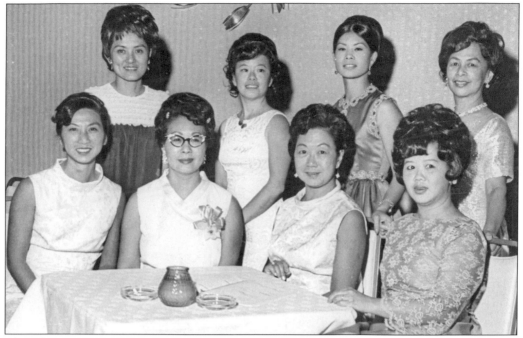

The Chinese American Women's Club (CAWC) was formed in the 1960s by a group of new arrivals to the Santa Clara Valley who joined to network and socialize with other young Chinese women. The members published a cookbook of favorite recipes so popular it went into a second printing and later a second edition. The club remains active today, serving members' social needs as well as the community. CAWC's early leaders, pictured above, are, from left to right, (first row) Helen Lee, Bertha Yee, Charlotte Shanen, and Millie Ho; (second row) Aimee Leung, Pat Jeung, Lillian Gong-Guy, and Ethel Chew. (Courtesy Ethel Chew.)

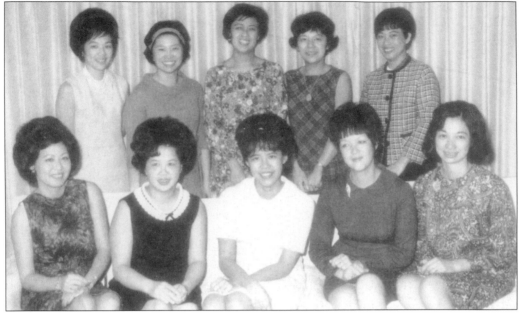

The Chi Am Circle, an Asian American women's group, has been a network for members interested in social and service activities since 1965. Its programs have included producing fashion shows, supporting senior projects, and awarding annual college scholarships. At a 1965 meeting are, from left to right, (first row) Rose Tang, Millie Ho, Shirley Wong, Pearl Lee, and Muriel Kao; (second row) Ruby Fong, Frances Quon, Gerrye Wong, Barbara Why, and Midge Tom. (Courtesy Gerrye Wong.)

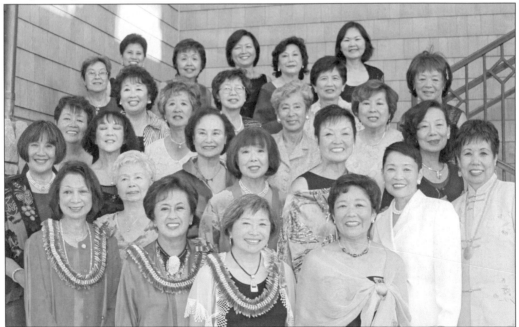

Chi Am Circle past-presidents celebrated their club's 40 years of service to its members' interests and community needs. Chi Am Circle members gather together from the communities of Saratoga, San Jose, Cupertino, Atherton, Los Gatos, and Los Altos Hills. (Courtesy Chi Am Circle.)

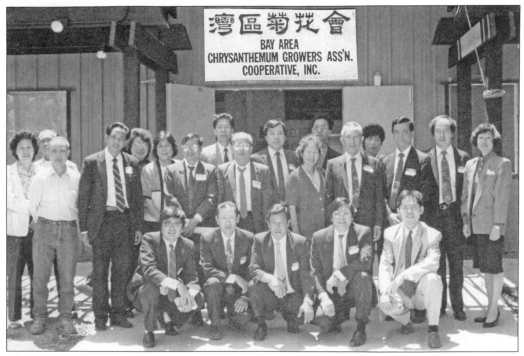

The Bay Area Chrysanthemum Growers Association (BACGA) was founded in 1956 and grew into prominence in the late 1970s. Members of the association are shown in front of their new building in San Jose. (Courtesy BACGA.)

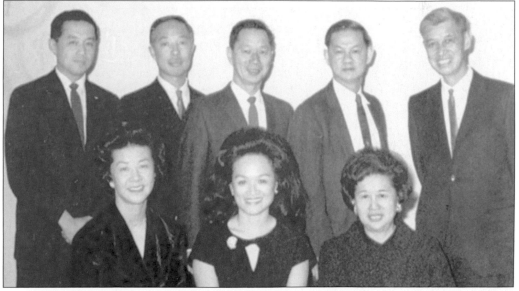

Founded in 1966, Stanford Area Chinese Club (SACC) established a Chinese language school and organized social and cultural programs. SACC's Chinese Cultural Fair, held from 1970 to 1984, was the first such festival open to the community in the valley, featuring Chinese foods, arts, games, history, and traditions. Founding leaders are, from left to right, (first row) Ruth Wing, Wilma Wong, and Louise Fong; (second row) Howard Ding, Hank Wong, Richard Young, Guy Wong, and Stan Moy. (Courtesy SACC.)

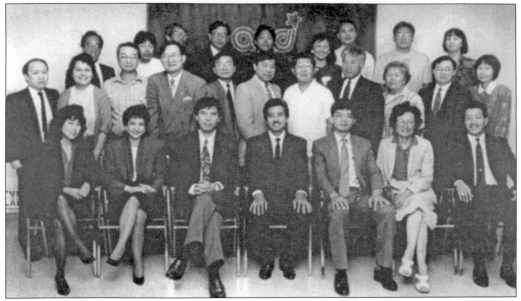

Asians Americans for Community Involvement (AACI) was formed in 1973 by a group of concerned citizens of the Santa Clara Valley who gathered to share issues and concerns facing Asian Americans. AACI has become the largest non-profit advocacy, education, health, and human service organization serving Asian Pacific Americans, providing more than 55,000 client visits annually. Pictured are the board members and staff in 1994. (Courtesy AACI.)

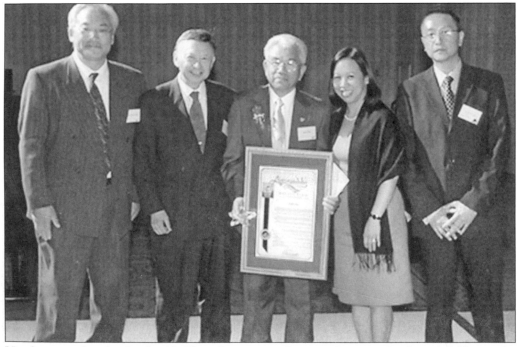

Headquartered in the Gordon N. Chan Community Services Center in San Jose, AACI provides youth empowerment advocacy and behavioral health services. From left to right, Paul Fong, Dr. Allan Seid (founder), and Paul Sakamoto are heralded by 2006 executive director Michele Lew and AACI board chairman Andrew Vu. (Courtesy AACI.)

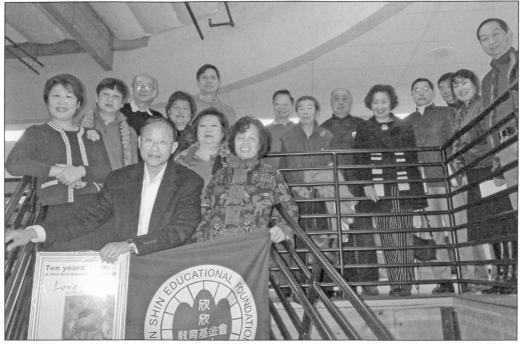

Sandy Chau (center), president of the Shin Shin Education Foundation, poses with founders, board members, and volunteers. The foundation was started in 1997 to construct and renovate primary schools in remote, rural, and despondent regions of China. (Courtesy Betty Yuan.)

Maria Chen (second row, third from left), one of the founders of Dimension Performing Arts (DPA), is pictured with volunteers. DPA was established in 1995, and their most recent success was the 2005 production *Kingdom of Desire*, an epic Chinese opera interpretation of Shakespeare's *Macbeth* at the California Theatre. (Courtesy DPA.)

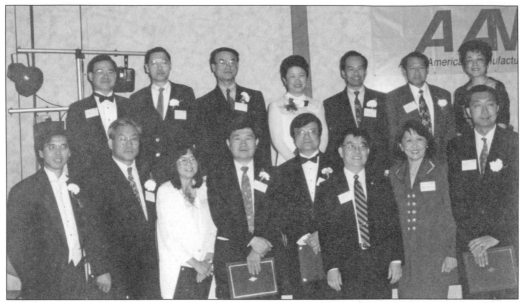

The Asia American MultiTechnology Association was founded in 1979 under the name of Asian American Manufacturers Association as a networking group for Asian high tech business owners. From left to right are (first row) Michael Chang, Paul Fong, unidentified, David Lee, unidentified, UC Berkeley chancellor Chang-Lin Tien, Rose Tseng, and unidentified; (second row) David Lam, Stanley Wang, unidentified, Bernadine Chuck Fong, Homer Tong, Ronald Kong, and Pauline Lo Alker. (Courtesy David Lam.)

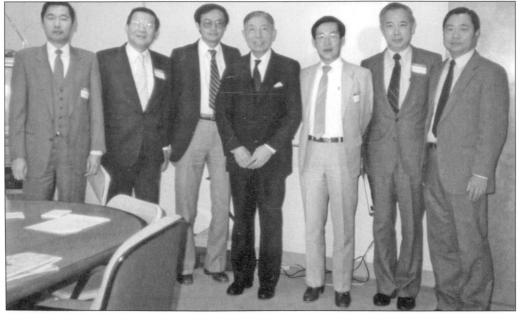

Established by high tech executives in Silicon Valley in 1993, Monte Jade focuses on entrepreneurship, technology, and investment and provides opportunities for members on both sides of the Pacific to exchange business ideas and information. From left to right are Stanley Wang, Joe Wu, Jim Koo, Taiwan chief policy maker K. Y. Li, Dr. Ling Nan, Lester Lee, and Dr. Yii-Der Chung. (Courtesy Monte Jade.)

The Chinese American Chamber of Commerce of the Santa Clara Valley (CACC) was established in 1985 to present a unified voice for local businesses and to cultivate participation in community affairs by Chinese American businessmen. CACC sponsors educational seminars and political forums and supports legislation beneficial to the Chinese American business community. Officers preside over a 1980s event. (Courtesy Dr. Roger Eng.)

The Chinese American Real Estate Association of Silicon Valley (CAREA) began in 1988, when founders Arthur Tom, John Luk, and Larry Chew (pictured from left to right) felt a need to promote and advance the image of Chinese Americans in the real estate profession. With monthly meetings for up to 200 people, the membership is exposed to a broad perspective of real estate opportunities and practices. (Courtesy Arthur Tom.)

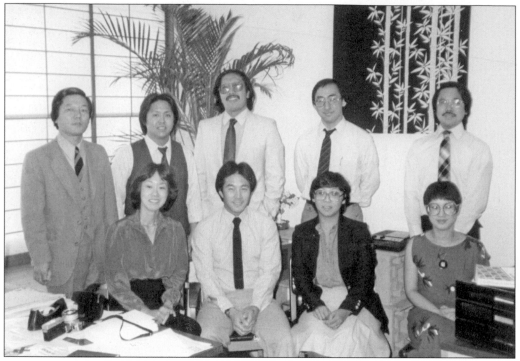

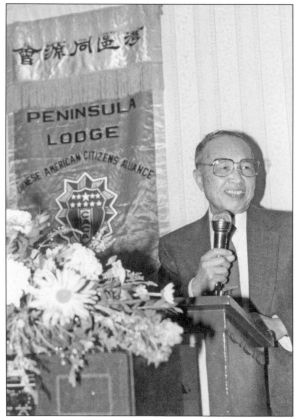

Asian Law Alliance (ALA) was founded in 1977 by Santa Clara University law students to provide legal assistance to the Asian/Pacific Islander communities. It has helped thousands obtain justice in the immigration process and access to basic legal rights. ALA leaders in 1982 are, from left to right, (first row) Joanne Hue, Steve Wing, Janice Doi, and Kathy Bui; (second row) Heng Seung Park, Larry Kubo, Glenn Sugihara, Richard Konda, and Stanley Yim. (Courtesy ALA.)

The Chinese American Citizens Alliance (CACA) Peninsula Lodge was chartered by the national organization in 1971. The CACA, a national organization founded in 1895 in San Francisco, continues its original mission to promote civil rights and the civic involvement of Chinese Americans. Peninsula Lodge's first president, Henry Gee, speaks at an early meeting in Mountain View. (Courtesy Dr. Roger Eng.)

Pictured in 1987, San Jose History Park executive director Mignon Gibson (left) discusses plans with Chinese Historical and Cultural Project (CHCP) cofounding chairpersons Lillian Gong-Guy (center) and Gerrye Wong on how to best display the historic altar artifacts from the original 1888 Ng Shing Gung temple in the new Museum of Chinese American history the CHCP would be gifting to the City of San Jose in 1991. (Courtesy *San Jose Mercury News.*)

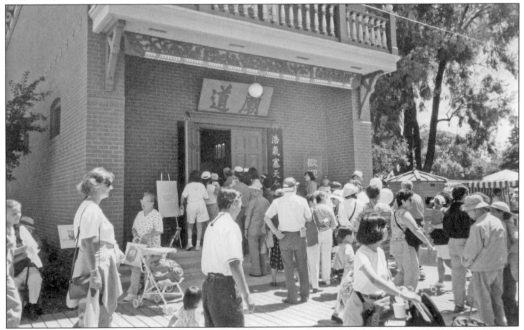

The grand opening day of the museum in September 1991 brought out throngs of young and old people eagerly waiting to see the Ng Shing Gung museum following the ribbon cutting. Since the 1991 opening, thousands of children, their parents, and tourists have toured the building and shared it with others. (Courtesy CHCP.)

Ng Shing Gung museum chairpersons Mildred (left) and Allan Chin (center) with Emily Yue discuss the layout of museum showcases, the historic altar, and the China/United States/San Jose timeline. Working with designer Daniel Quan, they are planning a grand opening for September 1991. (Courtesy CHCP.)

Teacher volunteers assisted CHCP in preparing the Golden Legacy teachers' curriculum guide on Chinese culture with accompanying lessons and crafts instructions. Here they are introduced to Santa Clara Valley teachers who are being given free copies for their schools. (Courtesy CHCP.)

HSJ chair Margie Matthews (left) and San Jose mayor Chuck Reed (center) is pictured with CHCP president Rodney Lum at the 2006 opening of the CHCP Museum Enhancement. Dr. Lum, besides guiding CHCP for five years, is spearheading efforts to preserve the historical remains of the Heinlenville Chinatown uncovered during redevelopment. In 2007, the county board of supervisors presented Dr. Lum with the Asian America Hero Award for his work. (Courtesy CHCP.)

Former California state treasurer Matt Fong congratulates CHCP leaders at the annual Chinese Summer Festival at History San Jose's Kelley Park. The festival, a free public event to encourage families to visit the museum and learn about Chinese culture through martial arts and dance exhibitions, craft booths, and cooking demonstrations, attracted over 10,000 patrons. Pictured from left to right are Matt Fong, Victor Wong, Pearl Lee, and Rosemarie Twu. (Courtesy CHCP.)

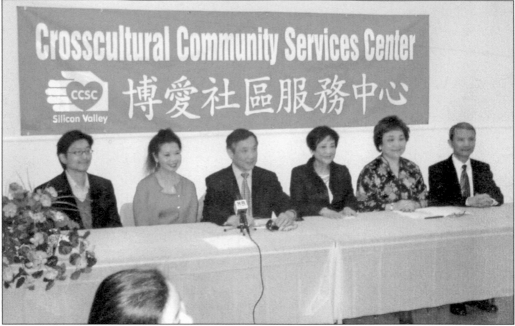

The Cross Cultural Community Service Center, a non-profit organization based in Sunnyvale, provides human and health services to Asian Americans and to the community at large. Board members gathered for recent event include, from left to right, executive director Christopher Chang, Kico Lin, 2006 president Larry Mao, Helen Lee, Maria Chen, James Su. (Courtesy Helen E. Lee.)

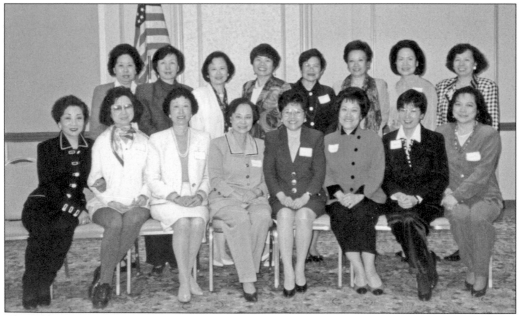

The Chinese American Women Business League was founded in 1994 by a group of Chinese American business women in the Greater Bay Area who shared a common goal of advancing the influence of Chinese American women in their business and professional lives. Members are pictured at a conference in 1995. (Courtesy Mabel Lai.)

The Organization of Chinese Americans is a leading national, non-profit, civil rights advocacy and education organization that is well represented by chapters throughout the United States. The Silicon Valley chapter was founded in 1991. Board members at a 2006 meeting are, from left to right, (first row) Albert Lee, Jeffrey Lee, Frank Chiang, Anita Yee, Julin Lu, and Gilbert Wong; (second row) Dennis Fong, Timothy Tom, and Albert Yu. (Courtesy Anita Yee.)

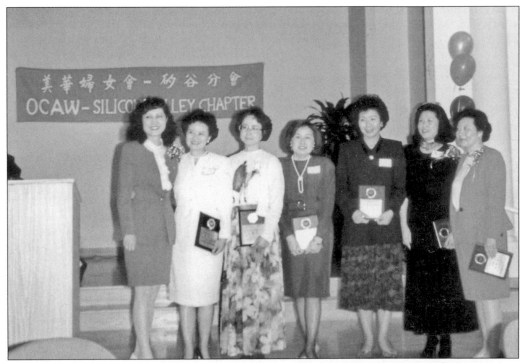

The Organization of Chinese American Women's Silicon Valley (OWAC-SV) chapter was established in April 1986, advocating the concerns of Chinese and Asian Pacific American women. OCAW-SV strives to strengthen educational, economic, social, and political opportunities for women and to encourage leadership. From left to right are Jenny Liu, Dorothy Lee, Grace Liu, Chia-Huei Chen, Cynthia Chang, Jean Chen, and Donna Tao. (Courtesy Cynthia Chang.)

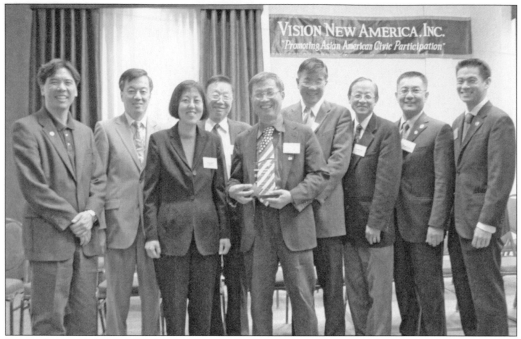

Started in 1996, Vision New America's mission is to increase the civic participation of underrepresented groups, starting in the Asian Pacific American community. With that mission in mind, Vision New America offers over 60 summer internships in elected official offices and government agencies. The board of directors and advisory board members are, from left to right, Michael Chang, Albert Wang, Belle Wei, David Tsang, Barry Chang, Hsing Kung, Sandy Chau, Kansen Chu, and Evan Low. (Courtesy Andre Nguyen.)

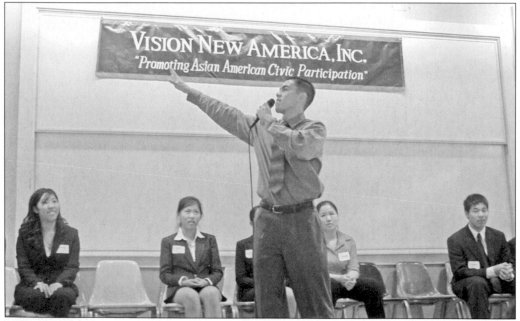

Vision New America intern Chris Do is pictured at a Public Policy Internship Program speech contest. (Courtesy Andre Nguyen.)

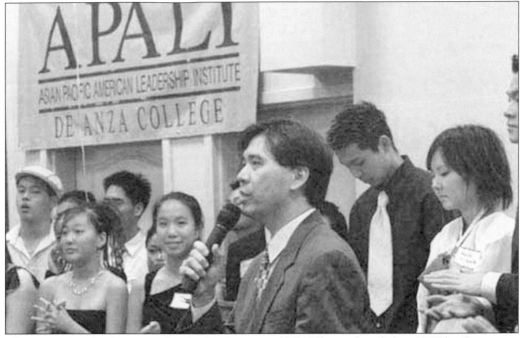

The Asian Pacific American Leadership Institute (APALI) was founded in 1997 by Cupertino mayor Michael Chang as part of De Anza College to educate and mentor effective civic leaders from minority communities. APALI graduates serve on boards and staff of many non-profit organizations as well as in government as elected officials, staff to elected officials, and as members of government commissions. APALI provides five acclaimed leadership programs for college and high school students, emerging community leaders, and public officials. (Courtesy Michael Chang.)

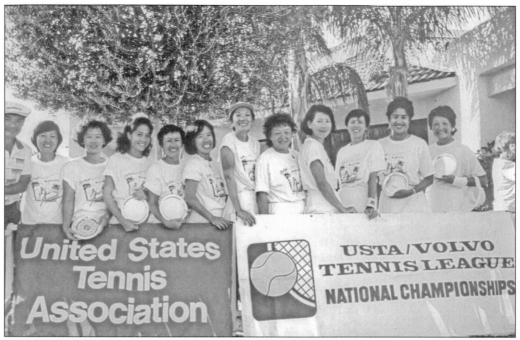

In 1989, the Las Palmas Chinese Women's Level Rating 3.0 Tennis Team, in their first year of competitive play, won the local, sectional, and state titles under the coaching of Jan Young. Entering the National USTA/Volvo League, which had over 1,000 competing players nationwide, this team placed fourth in the Palm Springs Finals. (Courtesy Jane Chan.)

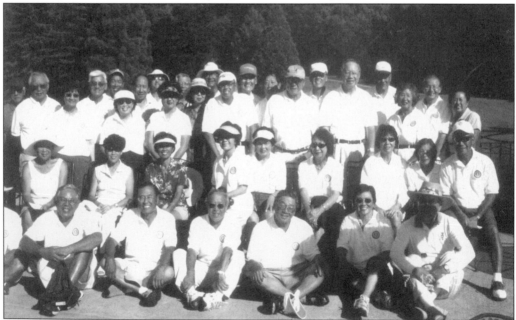

The Foon Hay Chinese Seniors Golf Club, formed in 2003, holds monthly tournaments for its 70 members throughout the Santa Clara Valley. It is a member of the United States Golf Association and the Chinese Golf Federation. Foon Hay means energetic and happy, which is an obvious characteristic of these senior golfers. (Courtesy Foon Hay Golf Club.)

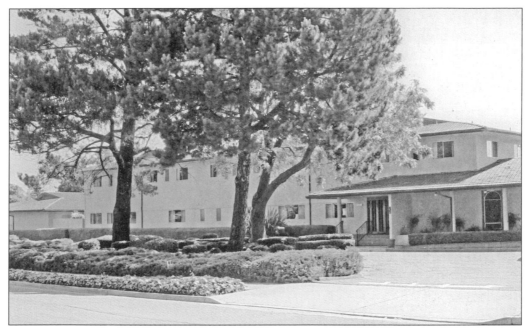

Amber Glow Eldercare Center, a 29,000-square-foot residential and senior center in the Willow Glen district of San Jose opening in 2007, is Self-Help for the Elderly's (SHE) newest project in its mission to promote the independence of older adults. Begun in 1966, this non-profit agency now serves over 25,000 seniors annually in San Francisco, San Mateo, and Santa Clara Counties. (Courtesy SHE.)

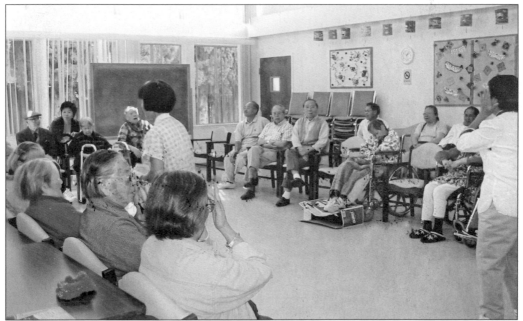

Zung Sieu Longevity Garden, SHE's first Santa Clara County assisted-living residential home, has provided social services, nutritious Chinese meals, and a caring home atmosphere for Chinese elderly for over 15 years. SHE is a multi-service organization providing social activities for seniors or assistance to the frail elderly. (Courtesy SHE.)

Asian American Cancer Support Network (AACSN) is a community resource network for Asian Americans affected by cancer in the Bay Area with social programs and creative fundraising. Pictured are, from left to right, (first row) Kasey Au, Fiona Chan, Abbey Chan, Kevin Handa, Evelyn Hsia, Amy Chen, and AACSN cofounder May Bakken; (second row) Doug Gor, Will Au, Doug Tsai, Donald Kwong, Jeff Tong, AACSN cofounder Fidelia Butt, and Hoon Im. (Courtesy AACSN.)

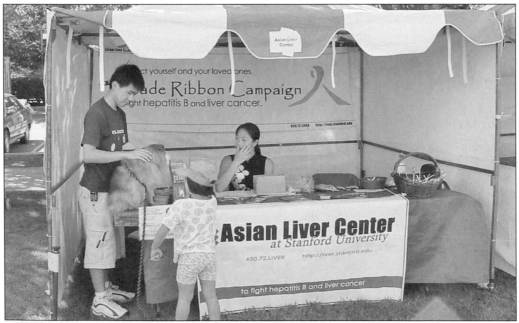

The Asian Liver Center (ALC) at Stanford University is the only non-profit organization in the United States addressing the high incidence of hepatitis B and liver cancer in Asian Americans. Founded in 1996, the ALC spearheads educational outreach in liver cancer prevention and treatment, relying solely on private donations and grants for its programs. Its Jade Ribbon Campaign promotes awareness of this disease. (Courtesy ALC.)

Family and community service are the focuses of the young women of the Organization Resolved to Charitable Events and Developing Sisterhood (ORCHIDS). ORCHIDS activities include providing meals and backpacks with school supplies to the San Jose Family Shelter, donating to the Asian Battered Women's Shelter, and organizing family picnics and craft workshops. (Courtesy Kelly Matsuura.)

First Thursday is a monthly dinner series for people in the non-profit, for-profit, and government sectors interested in Asian American and Pacific Islander (AA&PI) community issues and service opportunities. The group's mission is to foster a sense of community and understanding for Asian Americans and Pacific Islanders through educational events. (Courtesy First Thursday.)

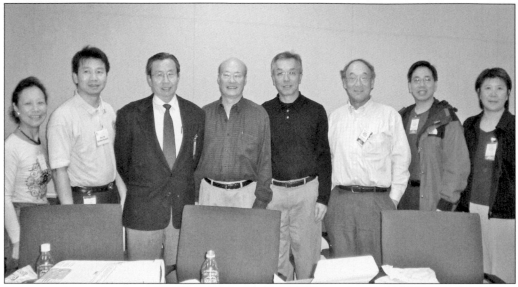

Corporate Asian American Employee Network (CAAEN) was founded 2004 as a collaborative network of Asian American employee resource groups in the Bay Area. CAAEN advisors, officers, and mentors from Committee of 100 at the Leadership Training Program 2007 are, from left to right, Joyce Chan, Ray-Zhan Su, Milton Chang, Albert Yu, Lee Ting, George Koo, Wayland Chan, and Gloria So. (Courtesy Ray-Zhan Su.)

The Hewlett-Packard Asian Pacific Employees Network (HAPEN) brings its mentoring group on a visit to the HP Corporate office in Pal Alto. In the background is the historic collection of early devices designed and sold by HP, a world leader in technology. (Courtesy Ray-Zhan Su.)

Four

A COMMUNITY ARISES

The Chinese in the valley have always created a sense of community for themselves. In San Jose Chinatown, traditions were strictly adhered to, and parents made their children attend Chinese school at the temple every day after American school. Elders practiced ancient Cantonese village customs and handed them unaltered to their children.

For new generations of Chinese Americans settling throughout the Santa Clara Valley, ethnic ties and cultural values remained important, but they began adapting their traditions and customs to American life. Coming together for a common interest or activity or joining a Chinese church, social group, or sports team has given young Chinese Americans a sense of pride and identity.

With arrivals to the valley from Taiwan and Mainland China, Mandarin has become the dominant dialect taught in classes. The customs and flavors of cities such as Taipei, Beijing, and Shanghai have broadened the scope of Chinese culture. Chinese schools, ever growing in enrollment, offer a range of cultural activities for youngsters who see the purpose and the fun of learning the language. Their parents are right, after all, in saying that Chinese is an important asset in the global community.

Chinese Americans have promoted an appreciation of their heritage at cultural festivals, civic events, and county fairs. The Chinese Cultural Garden, a five-acre site in Overfelt Gardens in San Jose, offers activity sessions to all the children in the community. The CHCP has hosted the Chinese Summer Festival, sharing music, dance, crafts, marital arts, and Chinese cuisine to thousands of guests. CHCP created a curriculum guide on Chinese culture and activities used in Santa Clara County elementary schools.

Chinese groups in the valley have given Chinese heritage a high visibility, making it familiar and accessible to all. Everyone knows when it is Chinese New Year. Any child can learn how to perform a lion dance or kung fu, to speak Mandarin, or to cook up a traditional Chinese dish. Experiencing Chinese culture and heritage has become part of Santa Clara Valley life.

Although many young Chinese Americans moved away from the pioneer San Jose Chinese community when they grew up, they often returned to their cultural ties and an important cause. In 1941, these active young women raised funds for the refugees in the China War Relief Drive by selling flowers at the Rice Bowl Benefit event in San Jose. From left to right are Lois Wong, Helen Kee, and Dorothy Chow. (Courtesy Gerrye Wong.)

The Los Gatos Ming Quong Home opened in 1935, providing a place for young girls of Chinese descent who were homeless due to family hardships or emergencies. Although older girls were housed in Oakland and San Francisco, the younger ones were moved to the Los Gatos foothills for a healthier environment. In 1953, Ming Quong was no longer needed by Chinese families. (Courtesy History San Jose.)

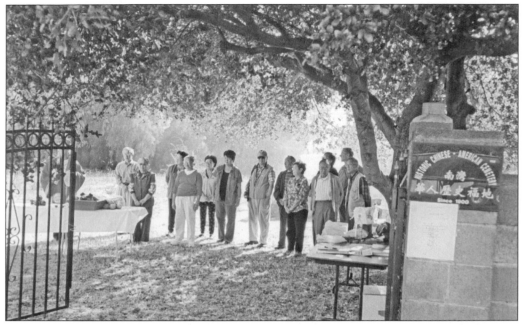

In the late 1890s, an area known as the Chinese American Cemetery was established adjoining the Oak Hill Cemetery in San Jose. Although time and vandalism have eradicated most burial markers, it is said that from the 1890s to 1964, more than 300 Chinese were buried here. Since 1979, the South Bay Historic Chinese American Cemetery Corporation (SBHCACC) has worked to maintain and commemorate this historic site. (Courtesy SBHCACC.)

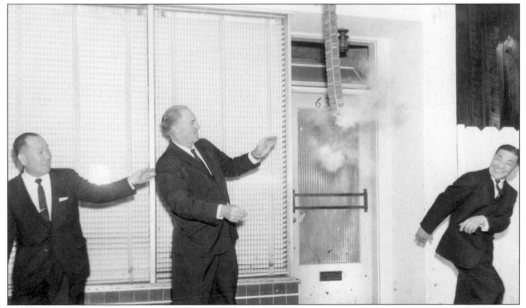

William Dair (right), president of Hop Sing Tong, opens Chinese New Year in 1962 by lighting a long string of fireworks in front of the headquarters on Sixth Street. In the center is supervisor Ed Levin of Santa Clara County. By inviting civic leaders and publicizing fetes, Dair made San Jose aware of Chinese traditions after the end of Heinlenville Chinatown. This street is now part of Japantown. (Courtesy Willis Dair.)

Doris Jew organized the first May Day Pet Parade in the 1930s in her hometown of Palo Alto. This parade continues to be an ever-growing annual event. From left to right are (first row) Emily Kwong, Ruth Mok, Mary Jane Toy, Barbara Jew, Dorothy Chan, David and Willy Wan; (second row) Mary Mock, Doris Jew, and Alice Kwong. (Courtesy Doris Jew.)

San Jose native Dr. James Lee grew up at 97 North Fifth Street, living above the family business, Pekin Herb Company, from the 1920s. Shown in 1940s are, from left to right, (first row) Mary Lee Chew, Anna Lee Wong, Mitzi Lee, Mary Wong Lee, and Clifford Wong; (second row) Dr. James Lee, O.D., George, Joe, Harry, Fred, Ann, and Lillian Lee, and Sheong Wong. (Courtesy Mitzi Don.)

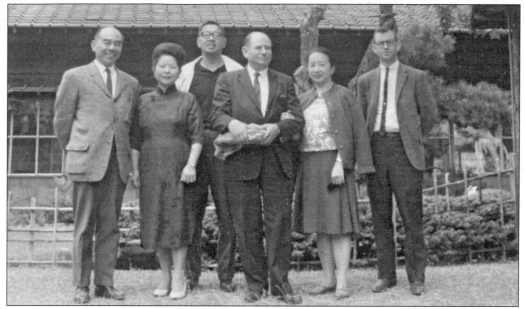

Four Chinese American families and the Greshams saved historic Hakone for all to enjoy. The partnership purchased the neglected property in 1961 and restored it to its original beauty and authenticity before selling the Japanese garden to the City of Saratoga in 1966. From left to right are John C. and Mary Young, Dan Lee, Joseph Gresham, Helen Kan, and Eldon Gresham. Not pictured are June Lee and George and Marie Hall. (Photograph by Johnny Kan, Courtesy Hakone Foundation.)

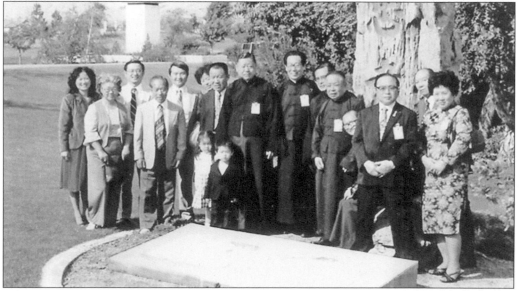

Frank and Pauline Lowe (front left) greet visitors following the installation in 1980 of the 15-ton black stone inscribed with the characters for loyalty. A bronze statue of Confucius stands in the background. The Chinese Cultural Garden was a 15-year, people-to-people collaboration between the Confucius-Mencius Society of Taiwan and citizens of San Jose. This project enriched San Jose's cultural environment by sharing China's ancient culture and philosophy. (Courtesy Sylvia Lowe.)

West Valley Chinese Language School presented a cultural showcase of ethnic costumes to students of the Cupertino and Fremont High School Districts in 1971 to introduce Chinese New Year traditions. The clothes were from Virginia Lee's personal collection. (Courtesy Wahnita Woo.)

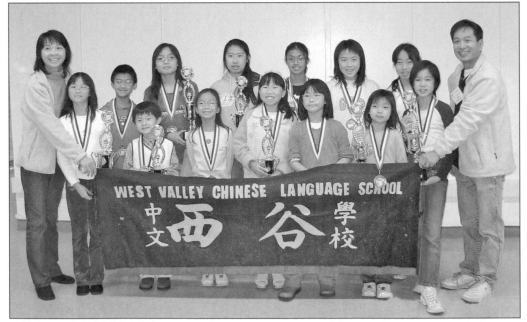

Opened in 1964, West Valley Chinese Language School is based at Homestead High in Sunnyvale and has an enrollment of over 400 students attending classes on Friday nights. Students are actively involved in the annual Association of Northern California Chinese Schools Academic Contest and have won many awards. Pictured in 2006 are student winners with vice principal Kammy Hsiao (left) and principal Billy Chow (right). (Courtesy Adelaide Wong.)

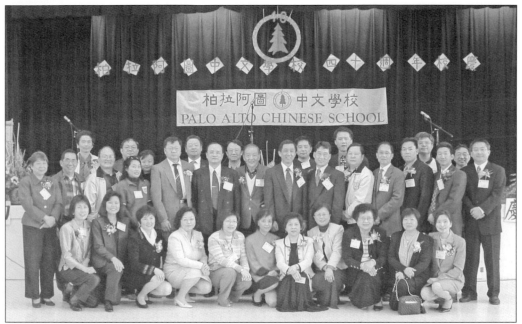

Founded in 1963, Palo Alto Chinese School (PACS) provided an opportunity in the community for K-12 students to learn Cantonese language and Chinese culture. The school celebrated its 40th anniversary in 2003–2004, and special guests, friends, and Chinese School principals were lauded for their long-term support. (Courtesy PACS.)

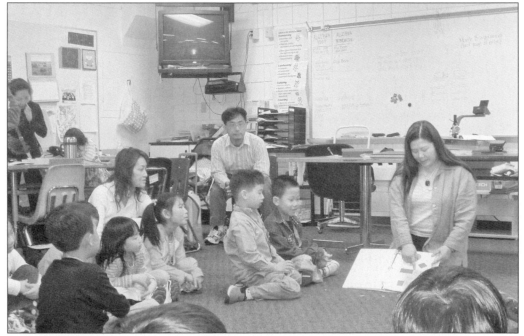

Berryessa Chinese School, started by Gilbert Chang in 1980, enrolled over 1,300 students with 66 classes, 35 cultural classes, and over 100 teachers. At one time, it was the largest weekend Chinese school in California and one of the largest Chinese schools in the United States. (Courtesy Berryessa Chinese School.)

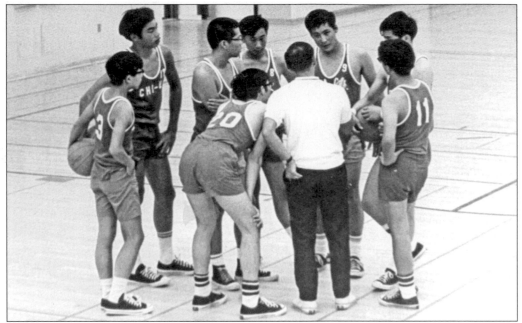

The Chi-U Teen Club, sponsored by the Chinese American Citizens League of Santa Clara County (CACL), organized a basketball team in the 1970s. Chi-U was formed so the youth of CACL members would have the opportunity to meet and interact with other Chinese teens. The basketball team, under coach George Chin, competed against other Chinese American teams in the Bay Area. (Courtesy CACL.)

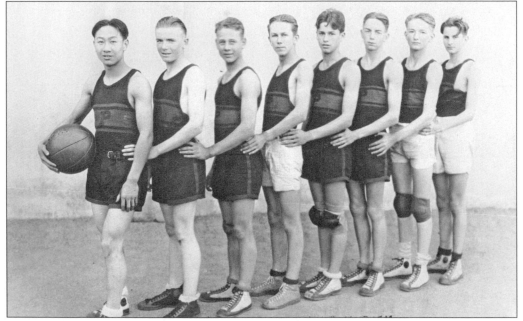

Growing up in a family that ran a Chinese restaurant in a Caucasian community, Hin Leung was undeterred by the anti-Asian attitudes of the time. A gifted athlete, Leung was captain of the Palo Alto High School junior varsity basketball team in 1925 and was a track star as well. (Courtesy Wally Leung.)

The Asian American Tennis Championships drew many tennis champions to compete for eight years in the 1980s. Organized by Sunnyvale's tennis director, Jan Young, at his Las Palmas Tennis Center, hundreds of tennis players and fans watched Asian American players vie for prizes. Seen with their winning silver platters are Tiffany and Trina Lee (second and third from the left), who went on to join college varsity tennis teams. (Courtesy Dr. Gary Lee.)

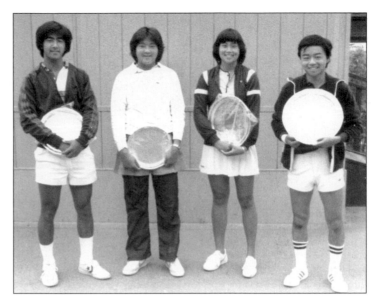

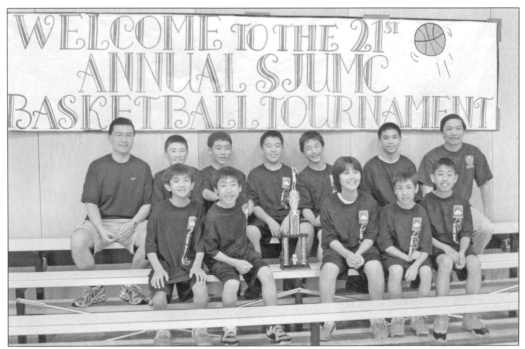

The Blaze basketball team, a member of the Tri-City Basketball League's C Division, was the happy champion at the SJUMC Invitational Tournament in Sacramento along with coaches Hubert Seid (second row, left) and Rick Watanabe (second row, right). Undefeated for the past two years, the boys from Los Altos, Mountain View, and Sunnyvale have enjoyed camaraderie with fellow Asian American junior athletes for the past six years. (Courtesy Dr. Michael Wong.)

The San Jose Christian Alliance Church (SJCAC) was established in 1975 to serve the Chinese community in Willow Glen by the Reverend Abraham Poon and his wife, Lillian. In 1987, they were the first Chinese to raise funds and build their own church facilities. The church has now grown to serve many multilingual and multicultural communities. Pictured in 1987 are Rev. Abraham Poon, wife Lillian, and daughter Serena. (Courtesy SJCAC.)

The San Jose Chinese Catholic Community (SJCCC) of the Diocese of San Jose was founded in 1983 by Chinese Catholic immigrant families in Silicon Valley. Today SJCCC is based in Santa Clara with a membership of over 800 families. Its mission is to foster spiritual development among its members and be actively involved in the community through its outreach activities. (Courtesy Isabel Chou.)

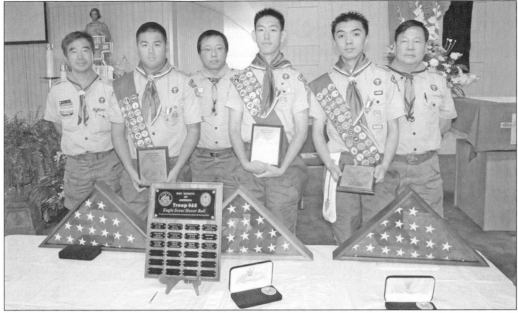

Boy Scout Troop 468 was founded in 1999, sponsored by Chinese American Scouting Association and serving Chinese American youth from Fremont, San Jose, and Milpitas. Pictured at an Eagle Scout Court of Honor ceremony are, from left to right, (first row) Eagle Scouts Timothy Ho, Gary Tao, and Matthew Wong; (second row) Scoutmasters Paul Hsieh, Terry Tam, and Larry Hsu. (Courtesy Brenda Wong.)

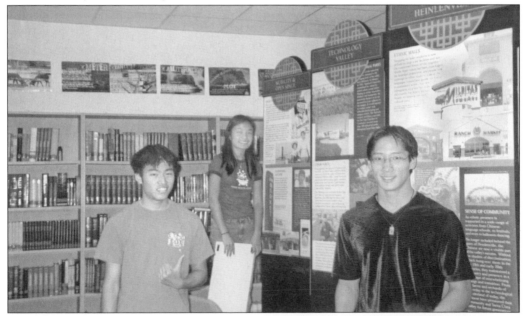

The Milpitas High School Chinese Club set up the Chinese Historical and Cultural Project traveling exhibit Pioneering the Valley in the school library during Asian Pacific Heritage Month 2006. The mission of the club is to strengthen student understanding and appreciation of Chinese culture through activities such as the annual Lunar New Year Show. Pictured from left to right are Hugh Nguyen, Brittany Huynh, and Sheng Huang. (Courtesy Brenda Wong.)

The Chinese American Women's Club of Santa Clara County previewed its 1997 *Chinese Cooking, Our Legacy* cookbook at the Fairmont Hotel with a special reception featuring chef Jimmy Lo from the Pagoda Restaurant. This updated version of *Chinese Cooking . . . Our Way* (1971) included home-style recipes, herbal remedies, and traditional dishes. Pictured from left to right are Ruth Fong, Ella Lee, Becky Quan Soffiotto, Helen Fong, and Sheryl Chan. (Courtesy Yucaipa Kwock.)

At the annual Chinese Summer Festival sponsored by the Chinese Historical and Cultural Project, local chefs share their Chinese cooking techniques and recipes with eager audiences throughout the day. Up to 10,000 patrons attend this cultural event each year. Seen here are Pax Cheng (left) of the Association of Chinese Cooking Teachers and chef Chris Yeo, owner of Straits Restaurant. (Courtesy CHCP.)

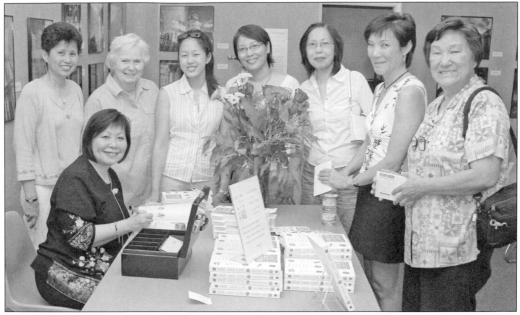

The CHCP Speakers Series, a membership benefit, offers topics of cultural interest in lectures and demonstrations. Rosemary Gong, author of *Good Luck Life*, is ready to sign her books. Standing from left to right are Speakers Series chairperson Susan Lew Lee; Kathleen Kvenvold, past president of the History San Jose Volunteer Council, Kathryn Lee; and several CHCP guests. (Courtesy Yucaipa Kwock)

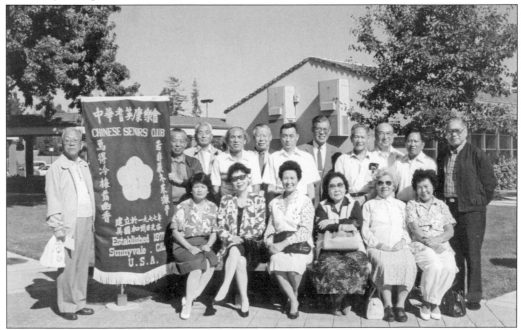

The Chinese Seniors Club (CSC) of Santa Clara Valley was established in 1977 under the sponsorship of Sunnyvale Community Services. Its 800 members enjoy classes in dancing, singing, tai chi, and English, among many others. It provides social outlet for many immigrant seniors. Volunteer board members are seen here in 1991. (Courtesy CSC advisor Nancy Wu.)

Welcoming visitors to the Ng Shing Gung Museum of Chinese American History in History San Jose Park are CHCP officers at a new exhibit's grand opening. Standing before the Timeline Exhibit, which chronicles historical events from 1850 to 2006 in China, America, and San Jose, are, from left to right, Carol Fong, Pearl Lee, Anita Kwock, Emily Yue, Connie Young Yu, Lillian Gong-Guy, and Gerrye Wong. (Courtesy CHCP.)

CHCP board member and awards chairperson Charlen Fong presents a Leadership award to Knight Ridder executive Tally Liu at the CHCP Shanghai Night Gala at the Santa Clara Marriott Hotel in 2003. (Courtesy CHCP.)

The art of lion dancing is an age-old tradition of Chinese culture that children enjoy seeing and participating in even more. Clifford Yip, member of the Chinese Community Center of the Peninsula, formed classes in the 1970s to teach Santa Clara Valley children this physical feat. He has taught generations of children in this art, having them perform in many local Chinese New Year parades for 20 years. (Courtesy Roberta Yee.)

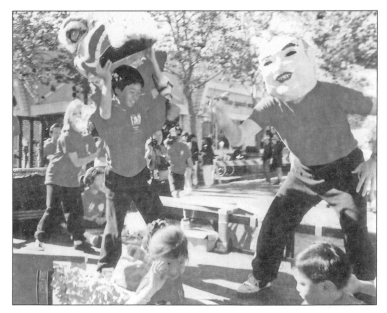

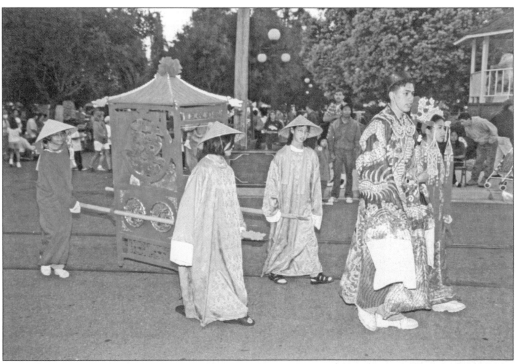

Volunteers at the CHCP's 1993 Chinese Summer Festival reenact the traditional Chinese wedding procession, where a bride is carried in an elaborate covered sedan chair to the groom's family village for the wedding ceremonies. In most cases, she is meeting her husband for the first time, as marriages were arranged by families through hired matchmakers. (Courtesy CHCP.)

Amy Woo of Sunnyvale was crowned 1986 Miss Chinatown USA in a pageant competition of Chinese American women from cities and towns throughout America. Sponsored by the Chinese Chamber of Commerce, the queen and her court represent the Chinese American community at many local and national events. The highlight of the queen's reign is a trip to Hong Kong and Taiwan. (Courtesy Wahnita Woo.)

Wun Mark, producer and founder of the Cantonese Opera Association–Silicon Valley, is pictured with Lo Wai Mun, managing director (center), Pang Hang Wah (left), and Lau Geen Foh (right), principle artists of the Ching Nin Guangdong Cantonese Opera Group. (Courtesy Wun Mark.)

Five

COMMUNITY LEADERS

From pioneer days, the Chinese excelled in what they did but were not given due recognition for their achievements. Although the contributions of these individuals left a lasting mark on our valley's development and progress, discrimination kept the Chinese in America obscured in history.

With fortitude and perseverance, early Chinese struggled to make a life for themselves in the valley and a better future for their children. They fought exclusion acts and unfair ordinances that kept them from participating in American life, and they opposed unconstitutional laws in the courts. Finally overcoming legal barriers, the Chinese began a full participation in American life that was denied to their forebears. At last, they were recognized for their contributions to California and took advantage of the social and occupational opportunities before them. There was a dramatic shift in the valley's demographics in the 1970s and 1980s brought about by the influx of overseas Chinese. Newcomers with high aspirations and skills joined forces with the second- and third-generation Chinese Americans spearheading progressive changes. With the advancement in civil rights for all minorities, a hopeful vision of a new society emerged. Chinese Americans stepped in to fill a void in representation and made themselves heard in the valley, determined to learn from the struggles of their ancestors and not to repeat the injustices of the past.

Leadership has many facets. There are those who lead by example, who volunteer selflessly to advance social service programs. Others lead by inspiration, their creative brilliance pointing in new directions; there are leaders who have extraordinary concepts in science, education, and the arts. There are yet others who step forward in the political arena, standing fearlessly in the public eye and serving the people. All have shown us that there are no limits. These exceptional individuals in their respective paths and disciplines have given us recognition and self-determination. More Chinese American leaders continue to emerge in this dynamic valley, redefining society and taking it forward.

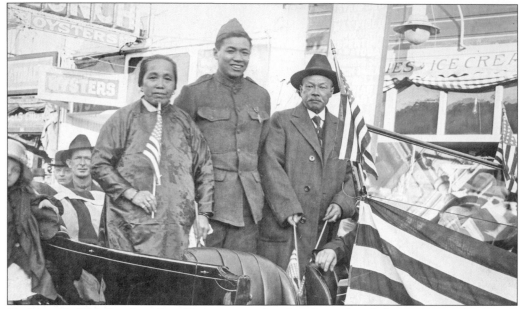

On June 13, 1919, Sgt. Lou Sing Kee receives a hero's welcome beside his parents in downtown San Jose. Under massive shelling and a gas attack, Sing Kee operated his signal station single-handed, securing the safety of his fellow Americans and saving a French unit as well. Receiving the Distinguished Service Cross and the Croix de Guerre, Sing Kee was the most highly decorated enlisted man in World War I from San Jose. (Courtesy History San Jose.)

Raised in the walled Chinatown of Heinlenville, George "Ming" Young was an outstanding sandlot pitcher who dreamed of flying. He became the first Chinese American with a transport license and went overseas to be a flight instructor for the Chinese Air Force. At age 27, he was killed on a training mission when the plane he was piloting crashed into a mountain near Canton in 1937. (Courtesy Connie Young Yu.)

Col. James C. Y. Leung, born and raised in Palo Alto, served in World War II and led a distinguished military career. Seen here in 1973, Leung receives honors at his retirement ceremony at the Presidio in San Francisco. He and wife, Vera, joined the family business, managing the Golden Dragon Restaurant for the next 27 years. (Courtesy Vera Leung.)

Chemist Frank Chuck, while working in the food industry, is credited with inventing the original process for producing powdered milk. Through his own Palo Alto company, Fla-Pana Research Laboratories, Chuck, a Stanford graduate, worked on the stabilization of vitamins for manufacture. He was the first Chinese American to serve as state deputy of the Knights of Columbus. (Courtesy Bernadine Chuck Fong.)

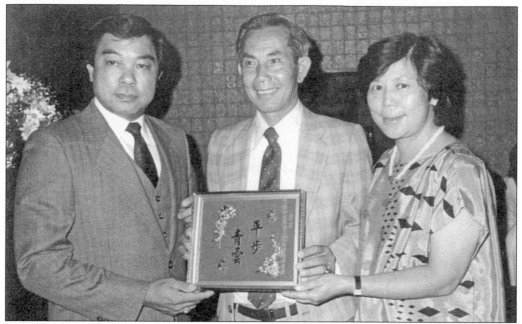

Gordon Chan (left), seen with wife Anita and William Mock (center) led his fellow flower growers to form the Bay Area Chrysanthemum Growers Association in 1956. His T. S. Chan Nursery was a leader for the Chinese in the commercial growing of roses in the 1980s. A respected leader, Chan was the first Chinese American president of the Santa Clara Farm Bureau and the Santa Clara County Planning Commission. (Courtesy Anita Chan.)

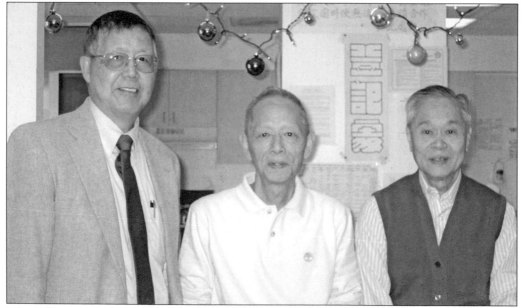

Victor Wong, left, has dedicated his retirement years from IBM to teaching English language and citizenship classes to hundreds of immigrant seniors in San Jose at Asian Americans for Community Involvement (AACI) headquarters. So popular are his classes, the elderly take busses and wait eagerly for his classes to begin. He received the Gordon Chan Community Award for his dedication to these seniors in need. (Courtesy AACI.)

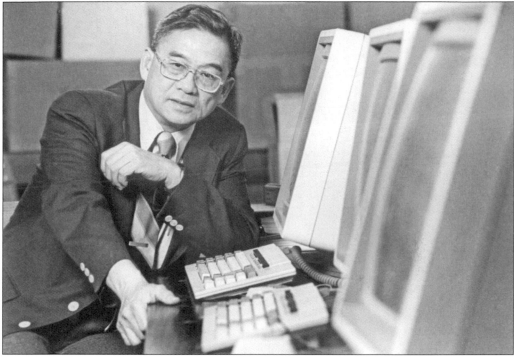

Prof. Shu-Park Chan, former dean of engineering at the University of Santa Clara, founded the International Technological University, the first Chinese American–established university in Silicon Valley. Chan also was appointed by Pres. George H. W. Bush to the J. William Fulbright Scholarship Board in 1991. (Courtesy Shu-Park Chan.)

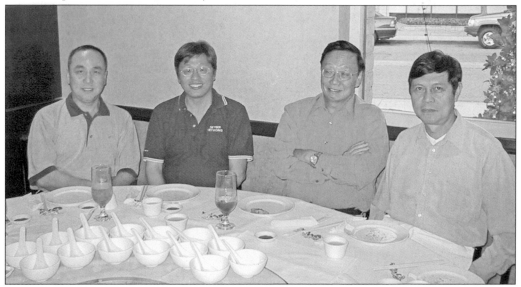

Bob Lin, Wu-Fu Chen, David Tsang, and Chester Wang started the first Chinese America venture capital firm, Acorn Campus Ventures, with its own technology and life science incubator in Silicon Valley in 2000. Acorn Campus quickly set an incubator in Shanghai handled by Tien-Lai Hwang to cross link business between the United States and Asia as business becomes more globalized. (Courtesy Chester Wang.)

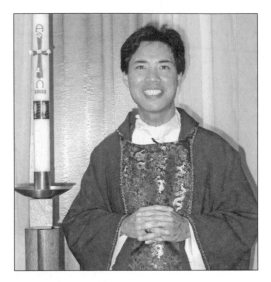

Rev. Gregory Ng Kimm is the first Chinese American pastor of a Catholic church in the Diocese of San Jose and the Santa Clara County. Born in Bakersfield, Reverend Kimm was pastor of St. Thomas of Canterbury Church in San Jose and currently serves at St. Joseph Catholic Church of Cupertino. (Courtesy Rev. Gregory Ng Kimm.)

Potentate Alvin P. Wong and his lady, Betty, served as the leaders of Shrine Islam Temple in 1990, traveling extensively to represent this organization, the third level of Masons. Previously he was master of Fraternity Lodge No. 399 of the Free and Accepted Masons in 1968 in San Jose. (Courtesy Anita Kwock.)

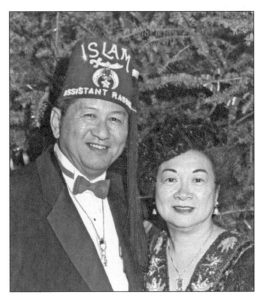

In 1968, San Jose native Leo Mark became venerable master of the San Jose Scottish Rite, a Masonic organization promoting civic responsibility and good citizenship. Active in the Chinese community, Mark was past president of the Chinese American Citizens League and the California District Attorney Investigators Association. (Courtesy Lillian Gong-Guy.)

Hong Kong native Kenneth Fong, often dubbed "Dr. DNA," founded Clontech, the first Asian American molecular biology company, in 1984 and built it into a leading, $38-million corporation. Named San Francisco State University's Alumnus of the Year 2006, Fong currently serves as a trustee for the California State University System and oversees Kenson Ventures. He is seen with his wife, Pamela. (Courtesy Ken Fong.)

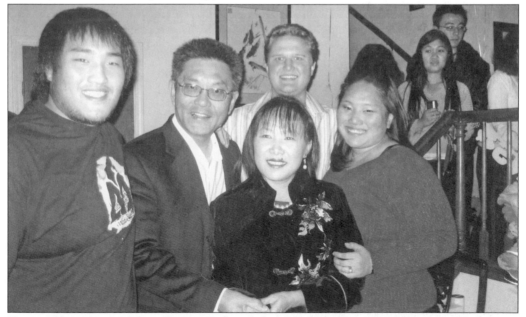

Kansen Chu emigrated from Taiwan and settled in San Jose. He was an electronics engineer at IBM for 18 years. Chu is on the Board of Trustees of the Berryessa Union School District and is the district director for California State Assembly member Rebecca Cohn. Pictured from left to right are son Walt, Kansen, wife Daisy, daughter Ann, with son-in-law Steve Blomquist in the back. (Courtesy Daisy Chu.)

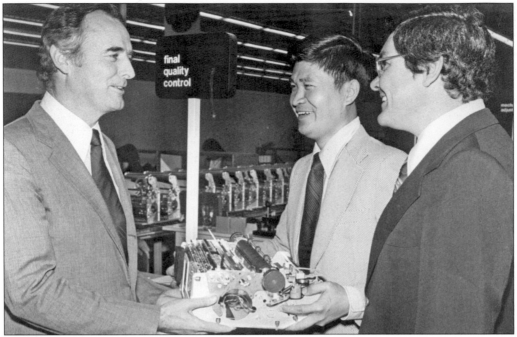

In 1969, David Sen-Lin Lee developed the daisy wheel, used in typewriters and word processors worldwide and capable of printing 30 characters per second. His technical expertise made Qume, which Lee cofounded in 1973, an industry leader. In 1978, he became the first Asian in the executive suite of America's top five U.S. companies when he became president of ITT Qume and chairman of ITT's business information systems group. (Courtesy Cecilia Lee.)

Dr. Robert Mah of the NASA Ames Research Center is pictured with the robotic neurosurgery Smart Probe device, a minimally invasive probe equipped with multiple microsensors at its tip for use in neurosurgery operations. He developed the device in August 2000. (Courtesy NASA Ames Research Center.)

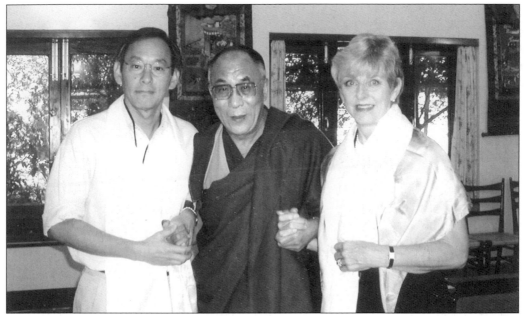

Steven Chu was a 10-year veteran professor of Stanford University's Applied Physics Department in 1997, when he was awarded the Nobel Prize in Physics, an honor shared with two associates. Their discoveries focusing on the "optical tweezers" laser trap were instrumental in the study of fundamental phenomena and in measuring important physical quantities with unprecedented precision. Chu is seen with the Dalai Lama. (Courtesy Steven Chu.)

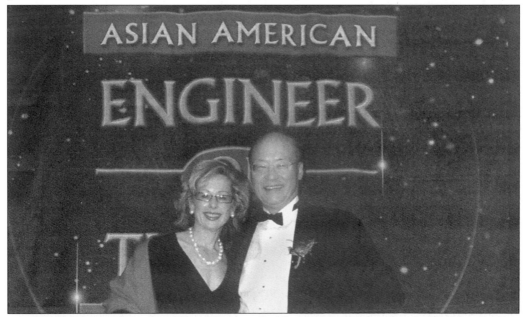

As senior vice president, Dr. Albert Yu propelled Intel to becoming the world's largest semi-conductor company. Author of *Creating the Digital Future and Insider's View of Intel*, Yu, the chairman of OneAngstrom, LLC, is involved in venture mentoring, and serves on the board of the Committee of 100. Pictured with his wife, Mary Beckmann, Yu accepts the Distinguished Lifetime Achievement Award from the Chinese Institute of Engineers. (Courtesy Albert Yu.)

In 2004–2005, Nicol Lea (second from left) was international president of Quota International, a charitable organization founded in 1919 that serves deaf and speech-impaired individuals, disadvantaged women, and children. She is seen visiting the Aruba School for Deaf supported by Quota Club. (Courtesy Nicol Lea.)

American Cancer Society's Chinese Unit founding member Tzu-I Isabel Chu (center) accepts the Lane Adams Award with national board chair Sally West Brooks, RN, MA (left), and national board president Carolyn Runowicz, MD. (Courtesy American Cancer Society.)

Flo Oy Wong uses themes of Asian America in mixed media installations exhibited nationally and internationally. A founding member of the Cultural Arts Commission of Sunnyvale, she served on Arts Council Silicon Valley. She has organized U.S.-China art and cultural exchanges. Standing by an image of her father, Wong explains Talk Story: An American Family at the Chinese Historical Society of America in 2006. (Courtesy Edward Wong.)

Fourth-generation Andrea Wong, after earning an engineering degree from MIT and a master's in business administration from Stanford, opted to become a television news producer in 1993. Sunnyvale native Wong, now president-CEO of Lifetime Entertainment Services, produced the Emmy Award–winning ABC series *Extreme Makeover: Home Edition*. Her *Dancing with the Stars* was the highest-rated television show in 2006. She is seen with grandmother Ada Mew at a White House reception. (Courtesy Laurie Albertini.)

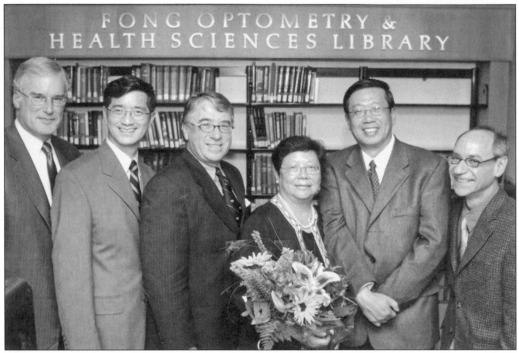

FONG OPTOMETRY & HEALTH SCIENCES LIBRARY

When Pamela Fong attended the University of California School of Optometry at Berkeley from 1974 to 1977, she noted the poorly furnished library. In 1999, her philanthropic spirit gifted a grant to rebuild the library and computer room. Receiving her grant are, from left to right, UC Berkeley vice chancellor Paul Gray, Dr. Weylin Eng, former UC Berkeley School of Optometry dean Dr. Tony Adams, Pamela and Ken Fong, and UC Berkeley School of Optometry dean Dr. Dennis Levi. (Courtesy Ken Fong.)

Bernadine Chuck Fong served as Foothill College president from 1994 to 2006, overseeing 18,000 students and 500 faculty members. A psychology and child development professor, Fong was named Phenomenal Woman 2002 by Chicago's Harold Washington College Chapter of the American Association of Women in Community Colleges. (Courtesy Bernadine Chuck Fong.)

Sunnyvale native Judge James Chang was the first Chinese American to serve as a Santa Clara County Municipal Court judge, serving from 1983 to 1989. Well respected in the community, Chang was appointed by Gov. George Deukmejian to the Superior Court, serving to 2003. In retirement, he continues working in the Assigned Judges Program. He is seen with his staff on his retirement day in December 2003. (Courtesy Judge James Chang.)

Santa Clara–born and –bred Judy Chu is seen being sworn in to the California State Board of Equalization on November 7, 2006, occupying one of the top-12 constitutional offices of California. She was mayor of Monterey Park for three terms and was a distinguished representative of the 29th Assembly District in San Gabriel Valley from 2001 to 2006. (Courtesy Judy Chu.)

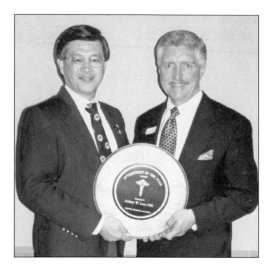

Well known for his professional and community work, Dr. Arthur Low is seen receiving the 1997 Optometrist of the Year Award from the California Optometric Association. Low also was the first Chinese American to be named the Campbell Chamber of Commerce's Citizen of the Year in 1994. (Courtesy Dr. Arthur Low.)

Emily Cheng, a Hong Kong native and graduate of UC Berkeley, served as mayor of Los Altos Hills in 2004. (Courtesy Emily Cheng.)

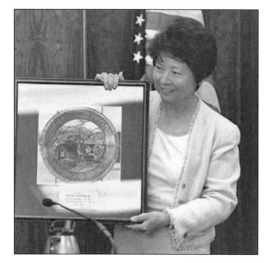

Mabel Lai received the Silver Bowl Award from the San Jose Junior League for her volunteer contributions to community. A former owner of Mabel's Lantern Restaurant in Los Gatos, Lai, who was born in China, has taught Chinese cooking classes to hundreds of students. She volunteers with senior citizens through Self-Help for the Elderly. (Courtesy Mabel Lai.)

Chinese American Silicon Valley mayors meet to discuss political opportunities for Asian Americans in the valley and United States at large. From left to right are (standing) former Cupertino mayors Patrick Kwok and Michael Chang; (seated) are 2007 Cupertino mayor Kris Wang and former Los Altos mayor Roger Eng. (Courtesy Kenneth Fong.)

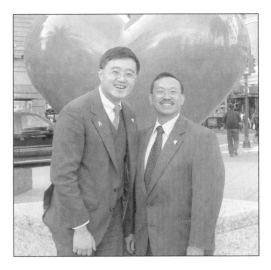

Sunnyvale mayors Otto Lee (2006–2007, left) and Dean Chu (2004–2005) have worked together on the city council since 2003. Otto, the managing attorney for Intellectual Property Law Group LLP, emigrated from Hong Kong. Dean, born and bred in Santa Clara, is a financial advisor of family investments and a former high-tech loan officer. (Courtesy Otto Lee.)

Aileen Kao, mayor of Saratoga, was elected unanimously by her peers in December 2006. She is a first-generation immigrant from Taiwan who began serving her Saratoga city council term in 2004. Kao previously served the Saratoga Union School District from 1998 to 2002. (Courtesy City of Saratoga.)

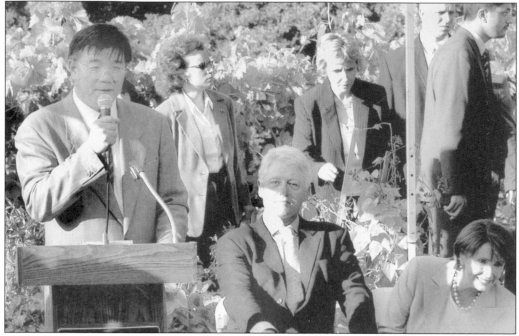

Dr. Hsing Kung, a pioneer of laser technology, founded a number of companies and took them public. An advocate of Asian American leadership, he has served on the boards of American Leadership Forum–Silicon Valley and the Foothill–De Anza Colleges Foundation; he was also board chairman of De Anza College's Asian Pacific American Leadership Institute (APALI), Vision New America, and Asian Americans for Good Government. (Courtesy Dr. Hsing Kung.)

Taiwan native Cynthia Chang served on the Saratoga Union School District Board from 1994 to 1998 and is the 2007 Los Gatos–Saratoga High School District Board president. As part of a new mentor program, she is seen with Los Gatos High School Student Board representative Mariana Shile reviewing a board agenda. (Photograph by George Sakkestad, Courtesy Cynthia Chang.)

Six

LASTING LEGACY

The history of struggle and the story of success are what Chinese Americans have given as a legacy to the valley, and this is indeed the making of legends. Pioneer families have descendants running family restaurants and corporations; some build industrial complexes, and others establish organizations that give back to the community. Highly successful Chinese Americans who care about preserving their heritage build museums, create historical exhibits, support education, and honor their elders. There are those who dedicate themselves to improving the health and welfare of others and who help children in need and care for the elderly.

In 1878, scores of youthful Cantonese were recruited to build a winding, torturous road to Mount Hamilton. A hundred years later, Chinese from Hong Kong, Mainland China, and Taiwan arrived in the valley to work on something that would change the way we all live and work. It wasn't a road or railroad this time—it was the technology of hard drives and software and the information superhighway. Chinese immigrants, risk-takers always, forged into uncharted territory and made innovation the by-product of the valley.

Second-, third-, and fourth-generation Chinese delved into careers undreamed of by their parents, making major discoveries in science and big waves in various media, mastering music and art, and becoming champions in sports. Profit is no longer the sole objective; all are still "going for the gold." Chinese Americans, finding a voice and a constituency, became heads of non-profits, city council members, planners, and mayors taking charge in the valley. At long last, ethnicity does not matter; only talent and ability do.

Most inspiring in this fast-paced region are those who "made it," who never forgot their roots and who look back at the struggles, hardships, and sacrifices of their ancestors from Gum San USA to Santa Clara Valley. They are the Chinese Americans from a myriad of vocations and pursuits who are keeping the legacy—the inspiring story of how they got here—so brilliant and alive for future generations to share and build upon.

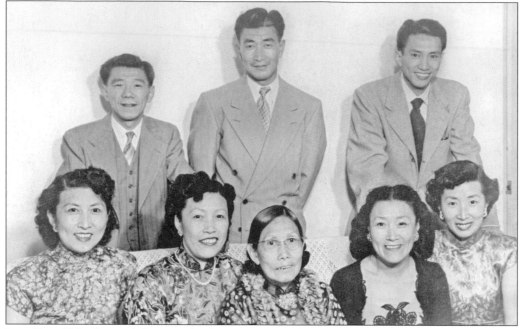

Lum Kaye Yoke (center), born in the Sonoma area in 1881, came to San Jose as the bride of Ng Kay Jom in the 1920s. San Jose Chinatown pioneers, they raised nine children in the store that was their home at 32 Cleveland Avenue. Gwong Lun Hang, the Ng store, was a center for clansmen working on Santa Clara Valley farms. Matriarch Ng is surrounded by her children celebrating her 70th birthday in 1950. (Courtesy Mitzi Don.)

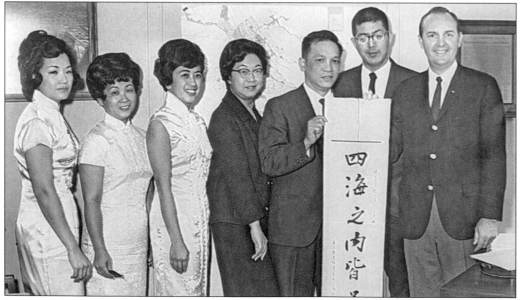

In 1968, the Chinese American Women's Club, Chi Am Circle, and Chinese American Citizens League present a calligraphy scroll to San Jose mayor Ron James during an official recognition ceremony heralding the community's participation and sharing of Chinese culture at the Santa Clara County Fair. From left to right are Mae Ding, Grace Gan, Gerrye Wong, Charlotte Shanen, Bob Lee, Victor Wong, and Mayor James. (Courtesy Robert Q. Lee.)

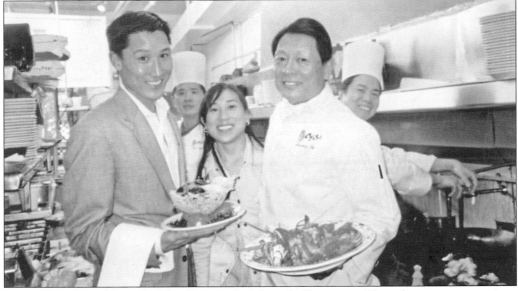

Larry Chew Jr. and Jennifer Chu Cruz, with father chef Lawrence Chew, form two generations making Chef Chu's of Los Altos the most enduring one-owner Chinese restaurant in the valley. In 1970, Lawrence opened Chef Chu's as the first take-out restaurant featuring Mandarin-style cuisine with only a 12-item menu. Chu continues to develop his cuisine, teaching cooking classes and leading gourmet tours to Asia. (Courtesy Lawrence Chu.)

Three generations of the Fong family are pictured together, with Art Fong (left), one of the first six engineers to join Hewlett-Packard in 1946; his son, Kevin (center); and his grandson, Michael. Kevin is a managing partner at Mayfield Fund and is leading Mayfield's China-based strategy and investments. Grandson Michael is a project manager at Maxim Integrated Products. (Courtesy Art Fong.)

Fifth-generation Chinese American Lisa Yuen grew up in Los Altos Hills, attending UCLA before her career on the Broadway stage. At 12, she played Dorothy in a local production of *The Wizard of Oz*, and she has appeared in national tours, Broadway shows, and television, acting in many non-Asian roles. (Courtesy Lisa Yuen.)

San Jose native Amy Chow, practicing gymnastics since she was three, gained fame as a teenage semifinalist at the 1996 Individual Event World Championships and won Olympic gold and silver medals in team and bars. She was a member of the first-ever American women's gymnastics gold-medal Olympic team in the 1996 games in Atlanta. She graduated from Stanford and became a medical doctor. (Courtesy Gerrye Wong.)

Jennifer Yu won the U.S. National Women's Foil Championship in 1990 and was the first woman to receive a fencing scholarship from Stanford. She was the captain of the women's varsity team, NCAA all-America, three-time Pacific Coast champion, and an alternate to the 1988 Olympic team. (Courtesy the Fencing Center of San Jose.)

Artistic Director of CPAA Yong Yao (left), seen with Ballet San Jose artistic/executive director Dennis Nahat, came from China to San Jose in the 1980s, giving up a dancing career and teaching position at a Beijing dance academy to follow his dream in America. Starting his own dance studio teaching Chinese dance, he has worked with Ballet San Jose to choreograph its collaborative production with Chinese Performing Artists of America, *Middle Kingdom, Ancient China*. (Courtesy John Gerbetz.)

Ann Woo is a pioneer in introducing Chinese performing arts to the American public. She founded Chinese Performing Artists of America (CPAA) in 1991 with professional artists from China as its core members. In 2004, Woo established CPAA Arts Center, the Bay Area's only multicultural and multidiscipline art school. Pictured with Woo are dance teacher Bing Wang, CPAA's principal dancer, and some of his students. (Courtesy CPAA.)

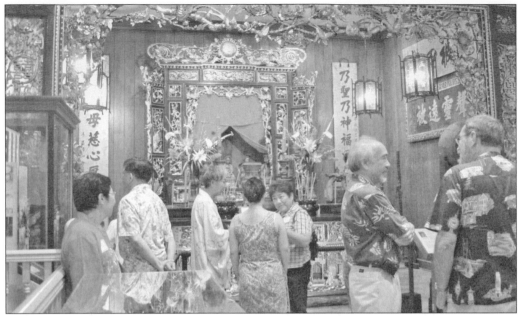

Made in Canton and brought to San Jose by the contributions of the Chinatown community, the altar was all that remained of the Ng Shing Gung temple, demolished in 1949. In 1990, volunteers of the CHCP painstakingly restored it to its original splendor. The altar is a major attraction at the replica temple, a museum of Chinese American history at Kelley Park. (Courtesy Marisa Louie.)

Another San Jose Chinatown surfaces with evidence of the early, vital presence of Chinese. Woolen Mills Chinatown (1887–1902) was uncovered by archaeological excavation preceding the expansion of Guadalupe Parkway (Route 87). Artifacts and images of the Woolen Mills can be seen at the Ng Shing Gung Museum in Kelley Park. Dr. Rebecca Allen (left), project archeologist is pictured with Connie Young Yu, historical consultant, in 1999. (Courtesy Past Forward, Inc.)

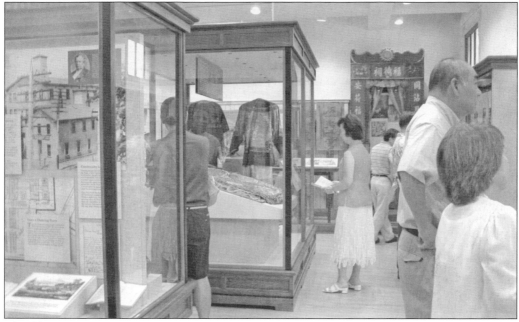

The Chinese Museum is a major attraction of History Park. The first floor tells the story of pioneer Chinese America in an engaging and captivating atmosphere. Visitors entering this replica temple can see elaborate 19th-century opera costumes, artifacts from three San Jose Chinatowns, and exhibits on the contributions of Chinese to Santa Clara Valley. (Courtesy Marisa Louie.)

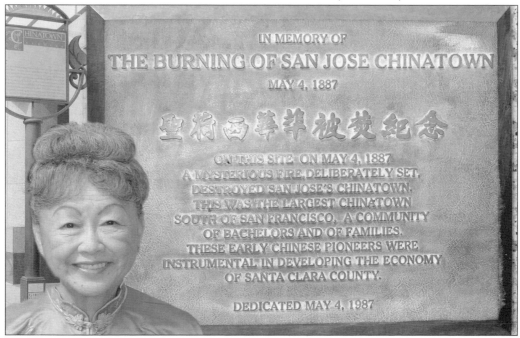

The Concerned Ethnic Chinese of Santa Clara County, led by Pres. Jeanette Zane, promoted the recognition of the San Jose Chinese, which resulted in a brass plaque and street marker at the site of the Fairmont Hotel on Market Street, the location of the first San Jose Chinatown. (Courtesy Yucaipa Kwock.)

Atherton resident Helen Chew was the first Asian American president of the Peninsula Volunteers, a women's senior service organization. She also was a founder of the Peninsula Children's Charter Auxiliary in the 1960s and is seen with members Judy Burdick (left) and Leah Chodorow at an event at Louise M. Davies's home in 1968. (Courtesy Larry Chew.)

Helen Leong, a 23-year veteran Stanford researcher, has been a tireless volunteer for the Peninsula Children's Auxiliary since the 1960s, working with mentally challenged children. She helped form the Peninsula Children's Center, now named Achievekids, which teaches autistic children learning skills to live independently. Serving on many non-profit service groups is her way of helping needy children. (Courtesy Helen Leong.)

Jessica Yu, receiving an Oscar in 1997 for her documentary, quipped, "You know you've reached new territory when your outfit costs more than your film." Yu's *Breathing Lessons* also won an Emmy. She has made other acclaimed documentaries and directed episodes of *The West Wing*, *E.R.*, *Grey's Anatomy*, and an upcoming Asian American feature film. A graduate of Gunn High School in Palo Alto, Yu's early work was *Homebase: A Chinatown Called Heinlenville*, shown at Ng Shing Gung Museum. (Courtesy Connie Young Yu.)

Debbie Gong-Guy (right) is seen with Jill Lawther (left) and Maggie Wellman. Debbie was the first Chinese American woman to serve as a chairwoman of the Junior League of San Jose Fashion Show fund-raiser. The 1992 Fashion Show chairwoman produced *Reflections* in celebration of the Junior League's 25th anniversary. Debbie also served as chairman of the board at the AEA Credit Union (now KeyPoint Credit Union), where she was on the board of directors for 10 years. (Photograph by Russ Fischella, courtesy Lillian Gong-Guy.)

Chi-Foon Chan (right) is the president and chief executive officer of Synopsys, a world leader in semiconductor design software. He is pictured with his wife, Rebecca (seated, left), an accomplished classical pianist, and Wendy Eng. A philanthropist of the arts and culture, Chan was named a distinguished fellow at the International Symposium of Quality Electronic Design in 2006. (Courtesy Wendy Eng.)

Dr. Jeffery Lee, DDS (left), seen with Walt Jue (center) and Dennis Fong, was on the executive board of CHCP. Dr. Lee was a lead member negotiating contracts with the City of San Jose to insure the museum's future. A member of Committee of 100, he is a founding board member of Self-Help for the Elderly, and a board member of AACI and the Angel Island Immigration Station Foundation. CHCP recognized Lee's untiring work and dedication with the President's Award in 2005. (Courtesy Susan Lew Lee.)

Jerry Yang arrived in San Jose as a 10-year-old from Taiwan. In 1994, Yang cocreated an Internet search engine that grew into Yahoo! with fellow doctorate student Dave Filo. A trustee of his alma mater, Yang cochairs the Annual Campaign for Stanford with his wife, Akiko Yamasaki. They are the major donors for the Environment and Energy Building, the university's hub of environmental studies. (Photograph by Alvin Chow, Courtesy the Stanford Daily.)

Carrying on the legacy of his family in public service, Evan Low became the first Chinese elected to the Campbell City Council in November 2006. His family traces back to Robert Locke, the first police chief of Campbell. His father, Dr. Arthur Low, O.D., was Campbell's Citizen of the Year and will be the 2008 president of Campbell. (Courtesy Yucaipa Kwock.)

ACROSS AMERICA, PEOPLE ARE DISCOVERING
SOMETHING WONDERFUL. *THEIR HERITAGE.*

Arcadia Publishing is the leading local history publisher in the United States.
With more than 3,000 titles in print and hundreds of new titles released every
year, Arcadia has extensive specialized experience chronicling the history of
communities and celebrating America's hidden stories, bringing to life the people,
places, and events from the past. To discover the history of other communities
across the nation, please visit:

www.arcadiapublishing.com

Customized search tools allow you to find regional history books about the town
where you grew up, the cities where your friends and family live, the town where
your parents met, or even that retirement spot you've been dreaming about.